GRAPHITE

CONCEPT DRAWING | ILLUSTRATION | URBAN SKETCHING

EDITOR'S LETTER

Thank you for picking up issue 06 of GRAPHITE magazine!

We're starting 2018 as we mean to carry on, with a host of great artwork and articles that we hope you enjoy as much as we do. In this issue you'll find vibrant urban sketches, fantasy folklore, a dash of sci-fi, and a dinosaur for good measure.

Our articles with Christian Reiske, Daniel Pagans, and Dwayne Bell will have you itching to get outside and draw, whether in sunny Spain or on an everyday bus commute. You'll also find some fun character inspiration with Jason Lee – this issue's cover artist – and Giselle Ukardi, tutorials for two wonderful illustrated scenes by Ulla Thynell and Anaïs Maamar, and Jordan K. Walker's impressive process for designing prehistoric creatures.

As always, you're welcome to send us your feedback via info@graphitemag.com, or drop us a message on one of our social media pages.

Thank you for reading!

Marisa Lewis
Editor

WHAT'S INSIDE

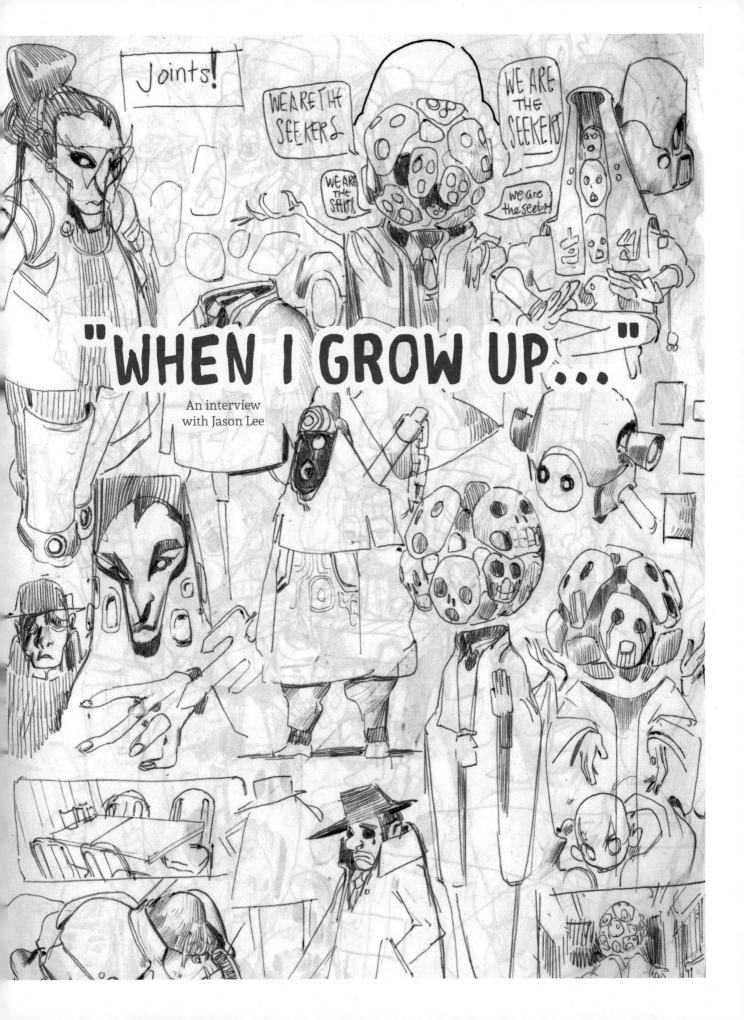

"WHEN I GROW UP...."

An interview
with Jason Lee

Illustrator and visual development artist Jason Lee creates dynamic, stylized characters informed by a love of all things animated. Discover the inspirations and processes behind Jason's artwork in this interview.

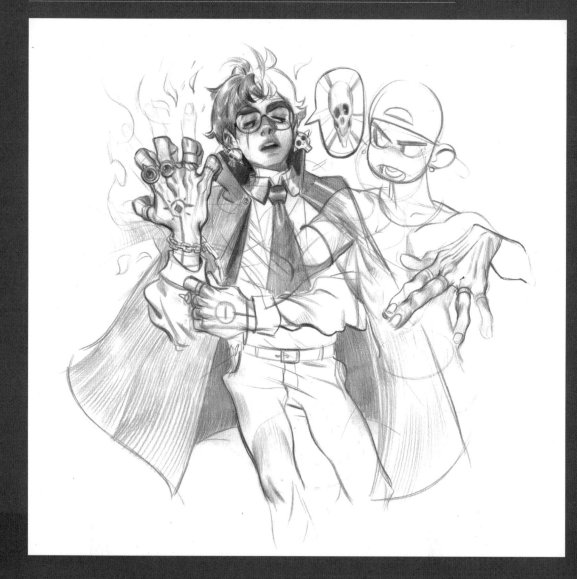

Left
Often my drawings end up merging and overlapping with other drawings

Right
A sketch from a mini-series of drawings about wizards and magic

Q· Hello Jason, thank you for speaking to GRAPHITE! Could you introduce yourself with a bit about you and your background?

A· It's an absolute honor and pleasure! I am a Korean-American artist based in the Los Angeles area of California. I always liked to draw, but only decided to pursue it during my last year in high school. After that, I attended the Art Center College of Design in Pasadena and graduated with a BA in Illustration with a focus on entertainment arts.

Q· Who or what are your major inspirations?

A· Things related to animation: animated movies, cartoons, anime, manga, and games. It is hard to pinpoint specifics. As a child, I would watch twelve or more hours of cartoons at a time until my parents cut me off. This resulted in me drawing a lot of fan art based on whatever I was into at the time. A lot of it was anime, since Toonami had just started rolling out shows like *Dragon Ball Z*, *Sailor Moon*, and *Gundam Wing*.

This habit of creating fan art continued on to many shows and artists, so I cannot really say which specific ones had the most influence on me, but I can say that because of animation, I look for action and life in drawings (like the work of Yō Yoshinari).

I also look for a sensibility and simplicity of design (such as the works of Shiyoon Kim and Minkyu Lee). I am always open to inspiration; it's one of the most exciting aspects of being an artist.

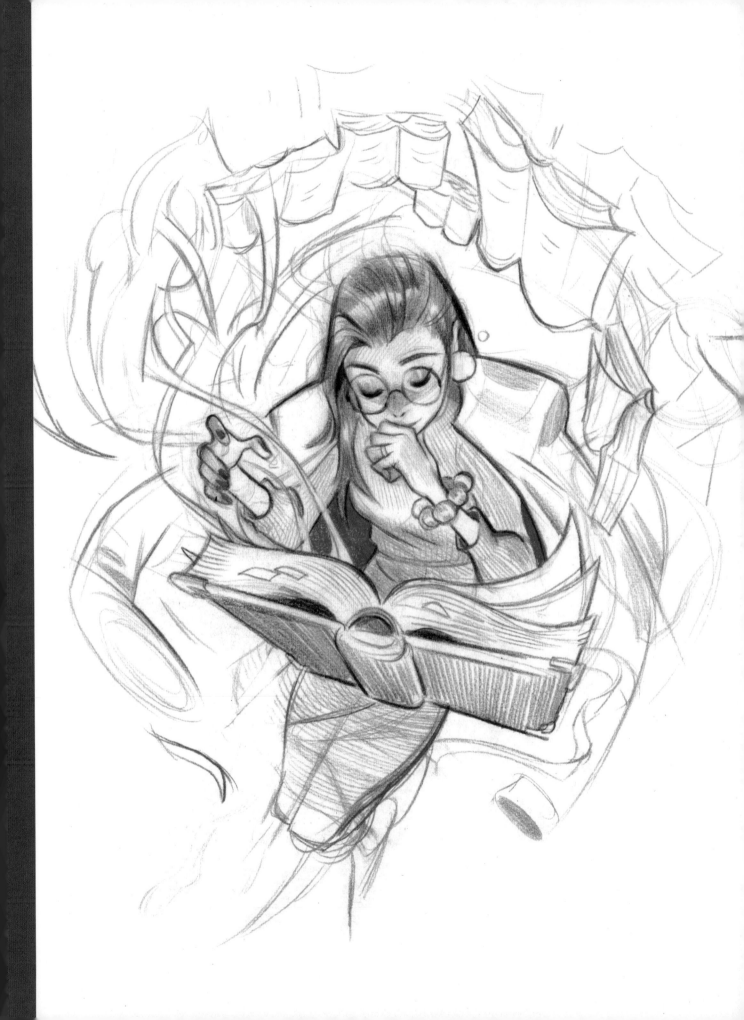

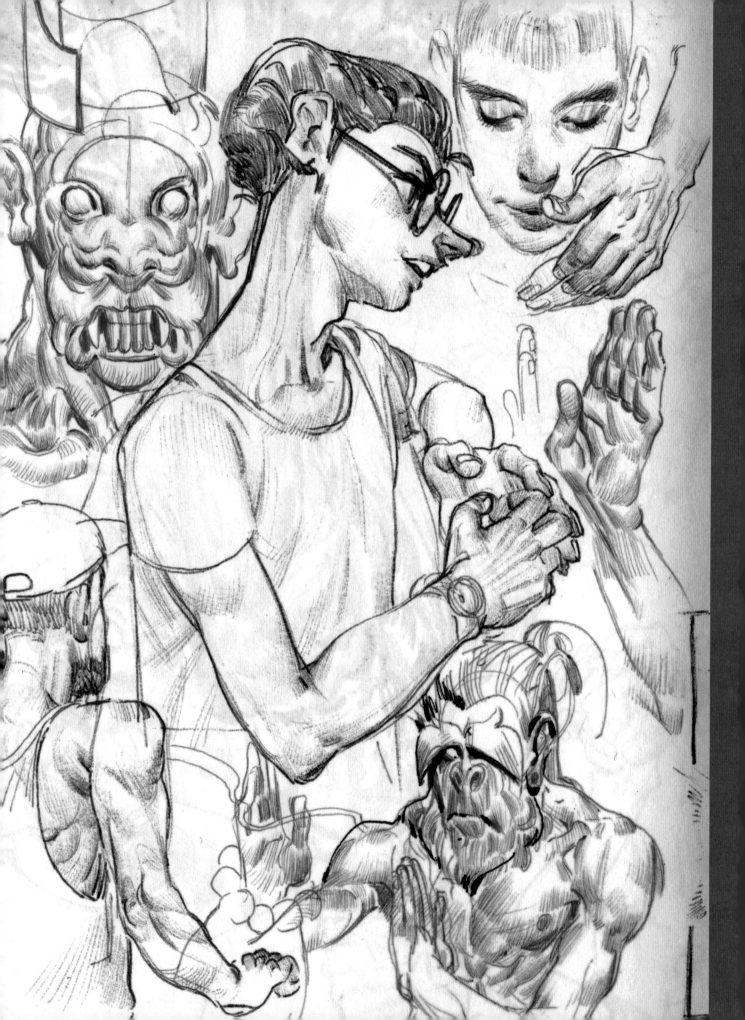

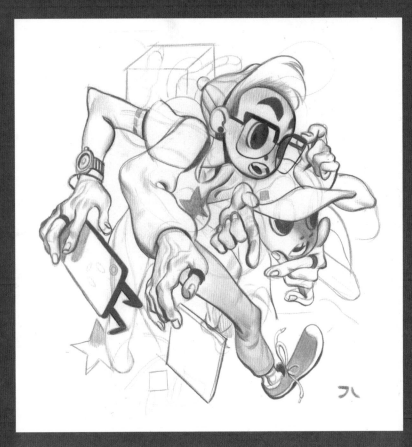

Q. When did you start seriously pursuing art as a career path? Or was there never any doubt about pursuing it?

A. I have always liked to draw, so as a child I would say I was going to be an artist. However, for the sake of my parents, I had to add other options to my future career possibilities. To "artist," I would add "doctor" (for my dad) and "pastor/missionary" (for my mom) in the "What I Would Like to Be When I Grow Up" sections of those questionnaires they gave us as ten-year-olds. It was not until my last year in high school that I thought about what I would enjoy doing for the rest of my life, and that's when I chose to be an artist. I am blessed for having been able to make it so far, and for having parents who ultimately support me all the way.

Q. What type of work do you love to make?

A. I love drawings and the physical act of drawing. Whether it is a quick observational sketch or an elaborately detailed doodle, drawing in a sketchbook or on a sheet of paper is just fun for me. So, more than the work I am making, I love just drawing. If the image comes out well, that's great! If it doesn't work out, I move on to the next sheet and try again. That being said, I have the most fun drawing characters, the themes and types of which vary according to the media I am inspired by in the moment. Lately, I have been having a lot of fun drawing and thinking about mages and wizards.

Far left
Messing around with an idea for a comic, using black and red ballpoint pen

Near top left
Experimenting with style and line with Carmine Red Prismacolor Col-Erase

Near bottom left
A zombie apocalypse-themed drawing for InkTober 2016, made with Carmine Red Prismacolor Col-Erase and Zebra brush pen

Left
The first drawing from my
magic-themed mini-series

Right
It's okay to make a
mess when you sketch

Q· You work with various techniques, both digitally and traditionally, but do you have a preferred medium? What is your drawing tool of choice?

A· I am learning to enjoy working digitally, but I love working with analog media. I enjoy it more because of the immediacy from tool to paper. It has a "there it is" aspect that I find challenging but rewarding. I get a thrill when I am sketching outside and hit that perfect line that captures the essence of the person, the action, or the object that I am drawing. When working digitally, I am more prone to finding myself polishing a drawing that doesn't work!

I like experimenting with different drawing tools and materials, but my go-tos are Prismacolor Col-Erase pencils (Carmine Red is the color I use a lot), Prismacolor Premier Black pencils, Staedtler Graphite pencils and lead holders, a 0.5 mm three-color ballpoint pen, and a black 0.4 mm Pilot G-Tec-C pen.

Q· How do you go about researching and developing a new concept? What do you think makes a concept successful?

A· I often just watch something and get inspired to think of characters or things that would belong in that universe. Then I trail off from there into my own kind of world. It's something that I did and still do a lot. While my friends played *Pokémon*, I would draw them. Eventually, I would create my own!

Sometimes I would combine series and designs, and end up with something amazing or abominable, like "Gokachu." The same process applies to designing a character from scratch, except I need a solid understanding of the character and their story beforehand.

Once I "know" the characters, what follows is just a lot of referencing, experimenting, and drawing until I feel the result is close to what I have in mind. A successful concept for me is one that is designed clearly and faithfully to

the character it is representing. Also, it should look cool.

Q· How do you approach your studies and self-improvement?

A· When it comes to self-improvement, I find it easier to study after identifying what I need to improve. From there, I find books, take classes, or search for information on the basics of that subject.

Once I have a handle on the information, it's just a matter of practicing and experimenting. I carry two sketchbooks with me wherever I go, just in case I find time to practice and draw, or in case I see something that I want to record.

Carrying sketchbooks offers the freedom to draw whatever you want, to make mistakes without ever having to show anyone. That gives me peace of mind, which allows me to have fun while studying.

Left
Sketchbook page of robots
and samurai, made with
blue and red ballpoint pens

Right
Drawing with Indigo
Blue and Carmine
Red Prismacolor
Cole-Erase pencils

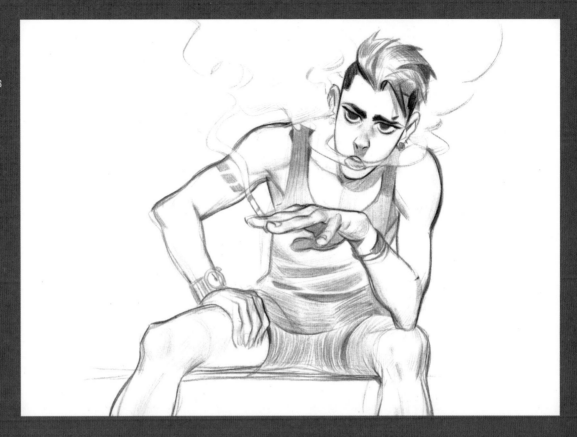

Q· What has been your approach to learning about anatomy and the figure?

A· Figure drawing and drawing from life. I have had wonderful instructors such as Will Weston, Jeff Smith, Kirk Shinmoto, and Dan Holland, who were able to break down and explain the design, functionality, and character of the human body but, ultimately, it came down to observing and digesting the information for myself via figure drawing.

Figure drawing is valuable not only for learning about anatomy and the figure, but for learning how to present or design that information with more weight, mood, character, story, and so on.

Nowadays, I do not have as much time or resources for figure drawing, but I still sketch whenever I get a chance. I have realized that just because you learn something once, it doesn't mean you will always have it at your disposal. It takes work to maintain that knowledge. I have got a lot of learning and

re-learning to do, but I don't mind, since it is honestly a lot of fun.

Q· What is one useful lesson you've learned in your education or professional career so far?

A· I have learned that everyone has their own pace at which they like to learn, grow, and even progress in life. It's okay if you are not at the place or skill level you would like to be at yet, so long as you keep doing your personal best. Be patient! What matters is consistency and having fun, and eventually things will come around.

Q· Could you tell us about some of your goals for your work or yourself in the future?

A· That list has been growing longer and longer! There are so many things I have been wanting to do and make, but I have a personal visual development project that has been haunting me for a while. I started it during my last year at the Art Center, and I definitely want to finish it and turn it into a book

before I move on to anything else. The project began in Ricardo Delgado's class about Jack the Ripper. I started off portraying Jack the Ripper the way he'd already been depicted, and was not very happy with that direction. I decided to try a different approach and made Jack the Ripper a child in an elementary school who murders toys!

I am having a lot of fun coming up with backstories and scenarios, and it's an opportunity to recreate classic crime and horror movie scenes with kids and toys. Hopefully I will be able to work on it and finish it soon – which I've been saying for the last couple of years!

Q· What do you get up to when you're not busy with art?

I really enjoy spending time with my friends, watching TV shows, playing games (I recently picked up poker), and eating some fantastic food; but nothing really beats just doodling in my sketchbook.

THE NEXT ADVENTURE

Sci-fi character design with Giselle Ukardi

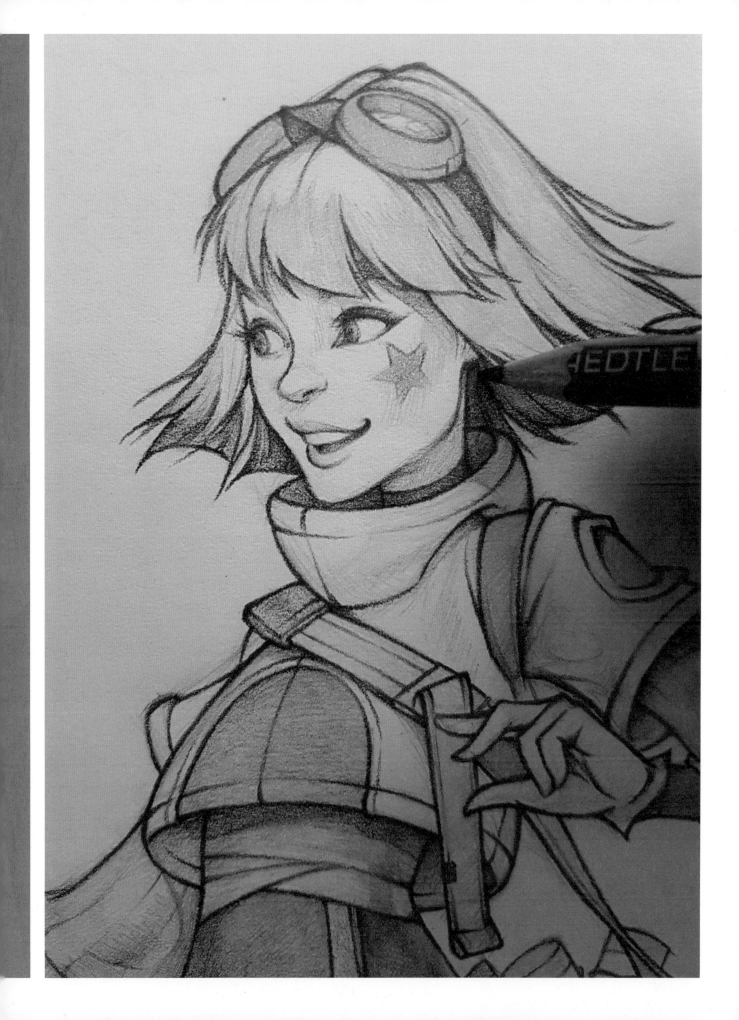

In this article, concept artist and illustrator Giselle Ukardi shares her process for drawing a character, from initial thumbnails to a final design rendered with pencil.

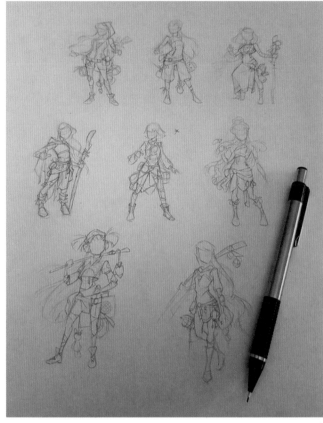

Getting started

The materials I am going to be using are very simple. I use a few different grades of graphite pencil: an H for light sketching and for blocking in shapes; a 2B mechanical for detail and line work as well as most of my rendering; and a 4B for areas of high contrast and final line work. As for erasers, I use a Tuff Stuff Eraser Stick, a regular white eraser for erasing larger areas if needed, and a kneaded eraser for lifting areas of graphite I might want to make lighter in value. Lastly, for this tutorial I'll be working on Canson 1557 Classic Cream Drawing paper.

Before doing any sketching, I like to start gathering reference. My aim for this tutorial is to design a female sci-fi or fantasy character, a type of wanderer or trader. I am unsure at this point which genre I want the character to be in, but I know the personality I want her to convey – the general "feel" I am looking for – and for me, that's a good enough start. I know that in the end I want my character to be fun, excited, and looking as if she's always ready for the next adventure. So with all this in mind, I gather some reference material before starting to sketch.

Thumbnailing

After I have gathered enough interesting images, I begin the thumbnailing process. Again, at this point, I have not decided which genre the character will be in, so I begin exploring both by quickly throwing down shapes (using a 2B mechanical pencil) to see if I can find a design that really fits the personality I have in mind. After some time exploring both genres, I settle on sci-fi, choosing the thumbnail I like best – a simple but lively pose. And now it's time to explore it further.

More thumbnails

After deciding on a genre and general "look" for my character, I begin sketching out more ideas. I did not explore the sci-fi theme very closely in the first round of thumbnails, so now I will sketch a few more ideas until I find a design that feels close to the character I initially had in mind.

Two of these thumbnails feel fairly close, but I still like the overall "feel" of the initial thumbnail that I picked out from the first round. I will stick with that general design and create several iterations based on it.

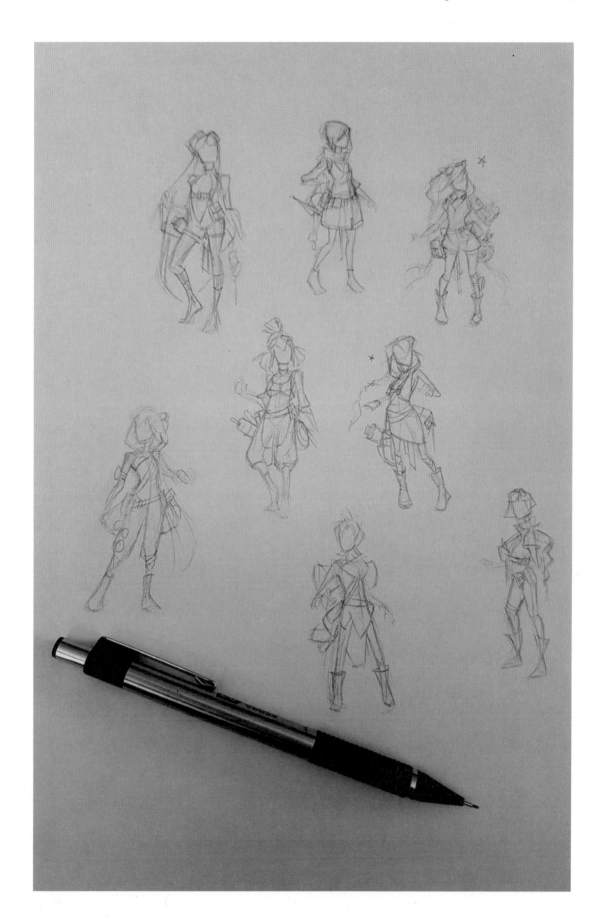

Far left
The drawing materials
used for this project

Near left
The first round of
thumbnail sketches

Right
The second round
of thumbnailing

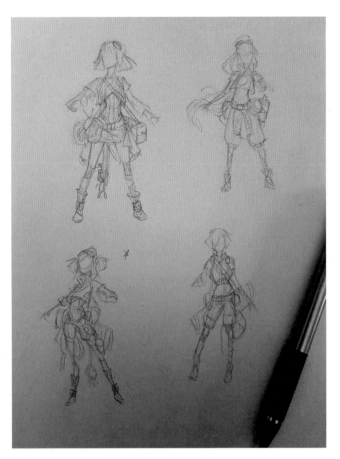

Quick iterations

Now I take my chosen thumbnail and explore its elements even further. I select pieces from some of my other thumbnails, introducing new elements, and just "Frankenstein" them all together to see if I can create a more fun, interesting, and playful design. After a few iterations, I am able to come up with something I like better; as you can see, it features some aspects borrowed from different thumbnails, such as the shorts and hair. With this new idea in mind, it's time to start the drawing process.

Basic shapes

On a sheet of Canson 1557 Classic Cream Drawing paper, using an H-grade graphite pencil, I start lightly blocking out the main shapes of my character. I am not concerning myself with any details at this point. The aim here is to outline the large and medium shapes to see if all the design elements are working well together. I do not have it all

decided just yet, so I continue playing around with shapes while settling on what I think works the best.

Finalizing elements

In this stage, my aim is to lock down most of the main elements that I will be working with all the way through to the final image. Of course, there will be plenty of room to change things and redesign elements along the way, but my main focus is to work out what my final design is going to look like. I use an HB mechanical pencil, still working lightly, to find the balance between large, medium, and small elements. Varying the sizes of the shapes in your design really helps to maintain a unified, interesting image.

First line art pass

I use an HB mechanical pencil to build up some basic line work and define the main details. You can see where I changed and improved some elements since the block-in

stage – for example, some of the items she's carrying now have more shape variety.

I add some basic detail work to the face and start thinking about how to spice up the smaller elements of the image. At this point I am applying a bit more pressure with my pencil, being more careful with my line work to ensure that I get a clean line with some subtle variations. The goal here is to establish the final design once and for all.

Above left
Design iterations based on the previous thumbnails

Above top right
Lightly blocking out the basic shapes

Above bottom right
Finalizing all the elements of the design

Right
The first pass to build up the line work

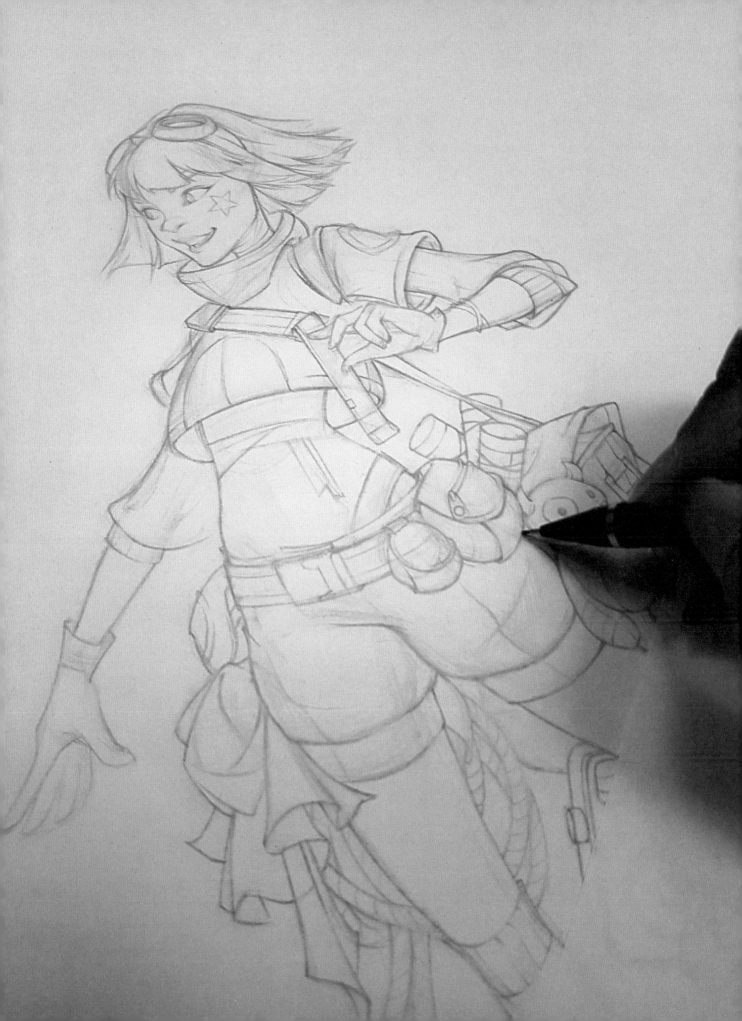

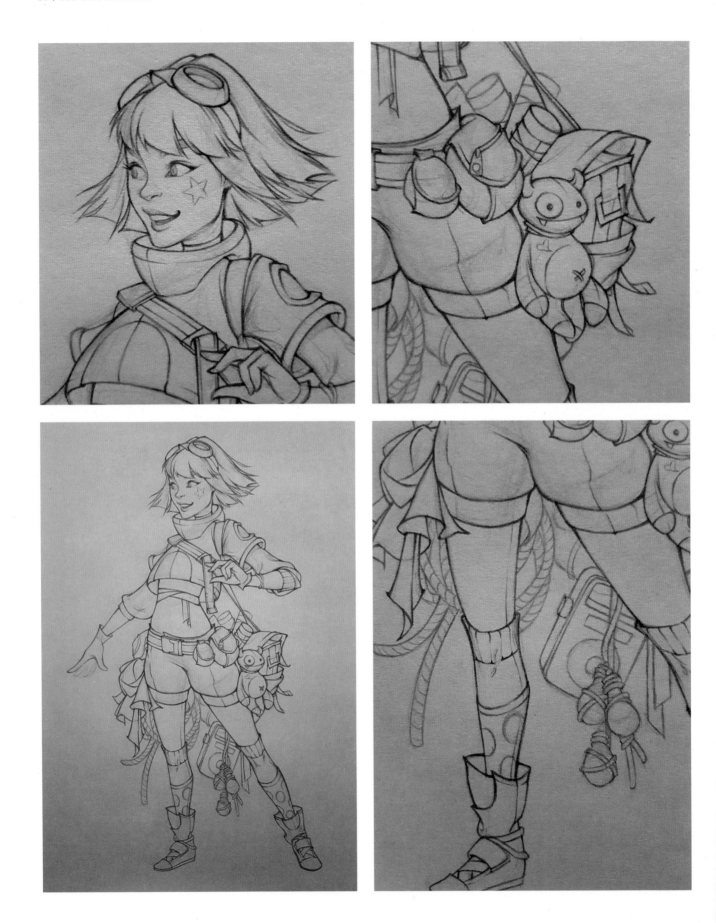

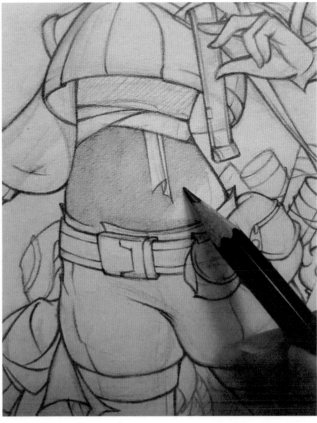

Top left row
Adding line variation

Far bottom left
Further line variation

Near bottom left
Leaving background
elements lighter to
create depth

Above
Applying an even layer of
basic tone to each area

Line variation

With my design decided and ready to go, I switch to a 2B mechanical pencil and start applying darker lines, aiming to strengthen the drawing's line weights. When developing line weight and variation, I mostly bear in mind where the light would hit the area I am working on; I leave lines slightly thinner and lighter in areas where the light would hit, and darker and thicker in areas where shadows would fall.

Detail work

Continuing with line variation, I add more detail to the face and secondary focal elements. The face is almost always the most important part of an image for me, so I make sure to take extra care when adding details here. I concentrate on the expression and whether or not it suits my character's personality; I want her to have a happy, excited look. I want the secondary focus of my image to be what's around her waist to emphasize the objects she's carrying, so I also

pay attention to those areas, making sure they are consistently drawn.

Leaving lighter areas

At this point, I also make certain stylistic decisions in my drawing approach, such as leaving some of the elements located behind the character lighter and less detailed. In this case, these are the radio, rope, and cluster of light bulbs she's got dangling from her bag. I find little tricks like this help to add some depth to the image, bringing the character forward while pushing the background elements back.

Basic values

When rendering, I use regular H and HB graphite pencils to lay down flat areas of value that I plan to render darker later in the process. I use the HB pencil for areas I plan on rendering much darker in value, and the H for any middle value areas. When planning out my values, I aim to strike a balance between dark, medium, and light tones.

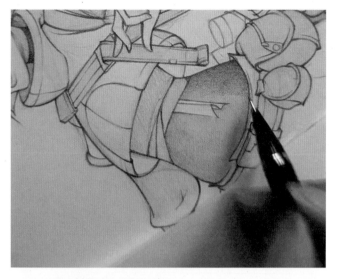
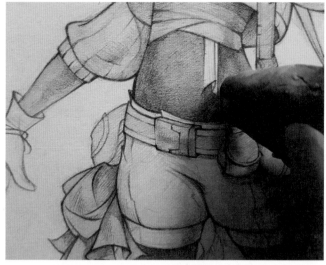
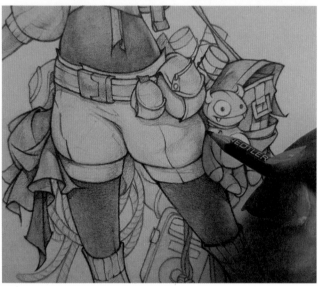
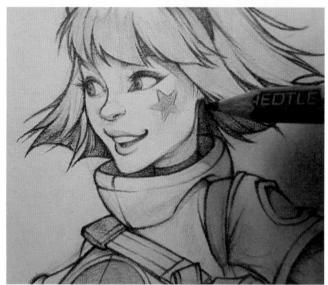

Introducing light

Now it is time to add the lighting. I return to using my 2B mechanical pencil and start applying some basic shading, paying attention to areas in light and areas in shadow. I start to think about cast shadows (shadows created by hanging or overlapping objects), and I keep in mind where my light is generally coming from (above the character). I am aiming for a stylized rather than highly realistic style for this drawing, so quite simple rendering will suffice.

Further detail

At this stage of rendering, I use my kneaded eraser to start lifting some areas that are currently too dark. In this case, I want to add more depth by creating areas of bounced or reflected light on the side of her torso, under her forearms, and on the sides of her legs.

Kneaded erasers are valuable tools for bringing light back into areas you may have intentionally or unintentionally rendered too dark. They are much more subtle than a standard white eraser, which makes them perfect for creating situations with bounce or reflected light.

Final line work

Once the rendering is complete, I can return to touching up some of the line work. I switch to a 4B graphite pencil to really darken my lines, pushing the contrast in the shadowed areas especially. Sometimes the initial line work ends up getting lost in the rendering process, so this stage helps to add punch to the values, making the drawing look more unified and complete.

Finishing touches

Continuing with the final touch-ups, I pick up my kneaded eraser again, using it to lift areas that I feel got too dark during the rendering stages. In this case, her upper legs look a touch darker than necessary, so I gently lighten them with the eraser. And now the image is complete.

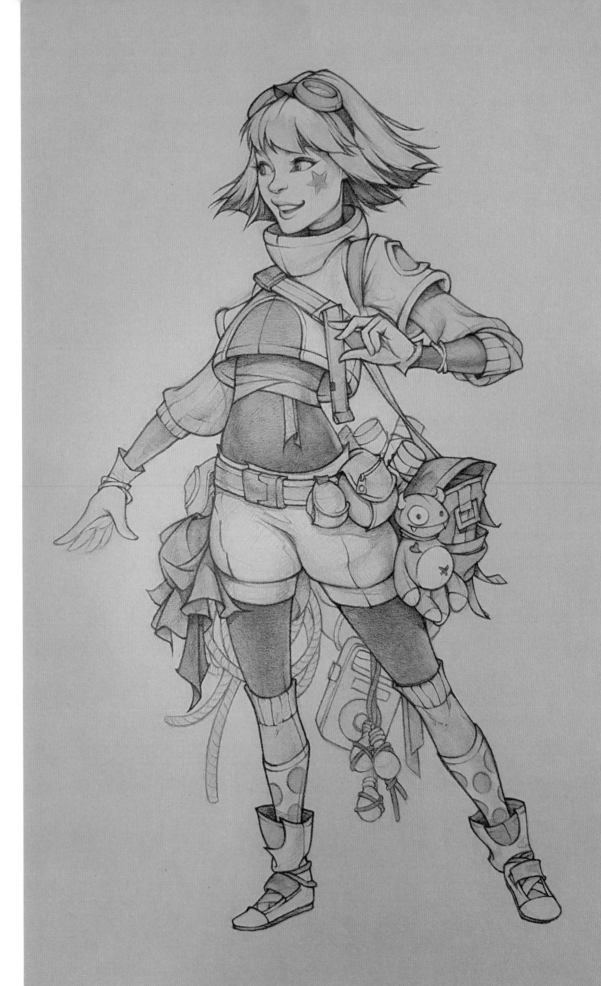

Top left row
Introducing light and
adding shadows

Bottom left row
More detail work

Right
Final image
© Giselle Ukardi

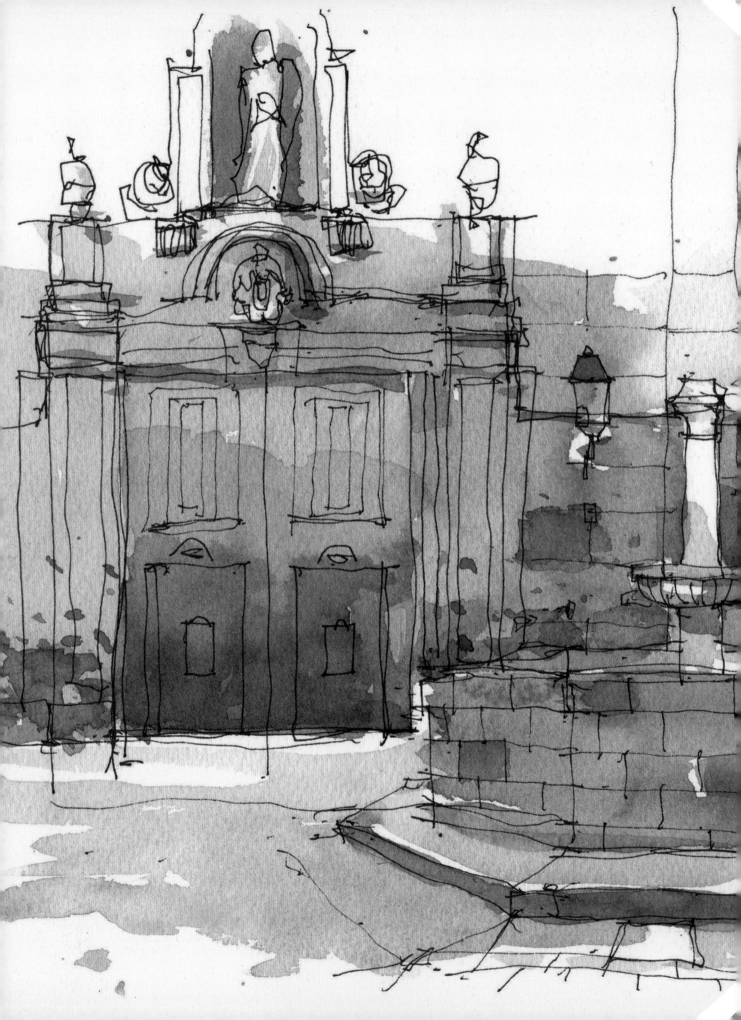

Barcelona in watercolor

Sketching on location with Daniel Pagans

Join illustrator and urban sketching enthusiast Daniel Pagans as he visits his favorite locations in Barcelona, Spain, to capture them with pencil, ink, and watercolor.

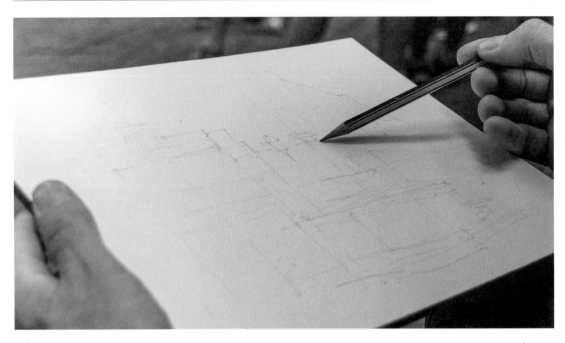

Left
Drawing the composition and basic structure in pencil, which helps to fit everything you want on the paper

Top right
Starting to ink. I use a Lamy fountain pen with an extra fine (EF) tip and Platinum Carbon Ink, which is black and waterproof

Bottom right
Adding the first light watercolors. The darks will be added later

My name is Daniel Pagans and I am a graphic designer and illustrator based in Barcelona. I work part-time as a designer and part-time as an illustrator and urban sketcher. Recently I founded the brand "drawing Barcelona," which was initially just an excuse to go out and draw different parts of the city.

Barcelona is the perfect place for urban drawing. It's big enough that there are always new places to discover, and it has year-round great weather for drawing outside! The project came out of a desire to document my experiences through drawing.

I began sketching a few years ago while traveling and living in various parts of Europe. After living and drawing in my favorite places in Bologna, Italy, for seven years, I returned home to Catalonia and began illustrating places in the city where I was born.

Now, continuing with the idea of "drawing Barcelona" I began "drawing on the road," a project where I share my travel sketches.

Urban sketching is a really interesting way to learn and improve your skills while having fun. It's an opportunity to get to know a lot of different people and discover beautiful places. When you draw a place, its details become imprinted on your memory in a deeper way.

In this urban sketching tutorial, I am going to show the process of my work with pictures and explanations. We are going to visit some locations that I especially like, and I will show a few different approaches and techniques.

Plaça de Sant Felip Neri

This square is in the old Gothic Quarter of Barcelona. The Gothic Quarter was the location of one of the most important Jewish Quarters in Europe during medieval times. The square itself is built on top of an ancient cemetery called Montjuïc del Bisbe.

Its current layout was established during the 1950s, when two buildings were constructed to be the coppersmiths' and shoemakers' guilds. The shoemaker's guild building is now

the city's footwear museum. Adjacent to these buildings is the eighteenth-century Baroque church of Sant Felip Neri.

The facade of the church is still marked from a bombing raid in 1938, during the Spanish Civil War, where forty-two people died – about half of them children running from the falling bombs.

I like to visit this square because it is hidden in the middle of the Gothic Quarter, the old part of Barcelona which is typically crowded. It is an authentic, relaxing place to sit and draw local life, withdrawing from the crowds while still being in the center of the city.

Each time I visit here, surrounded by the peace and quiet of the space, I'm reminded of the history of the location and the events which took place.

This drawing took about ten minutes to sketch, thirty minutes to ink, and thirty minutes to paint with watercolor.

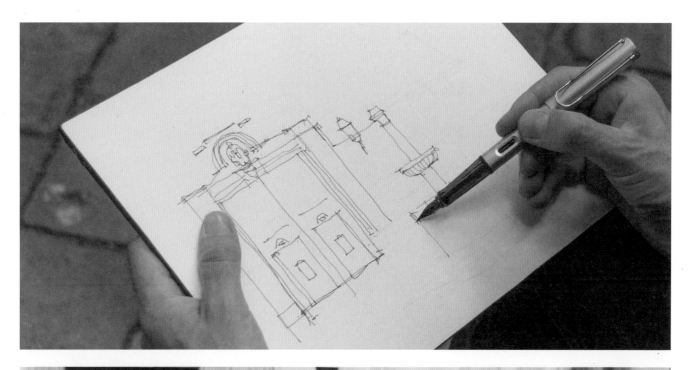

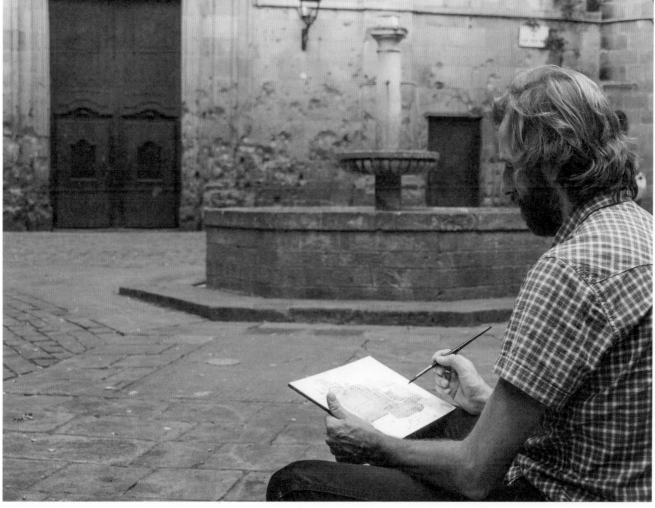

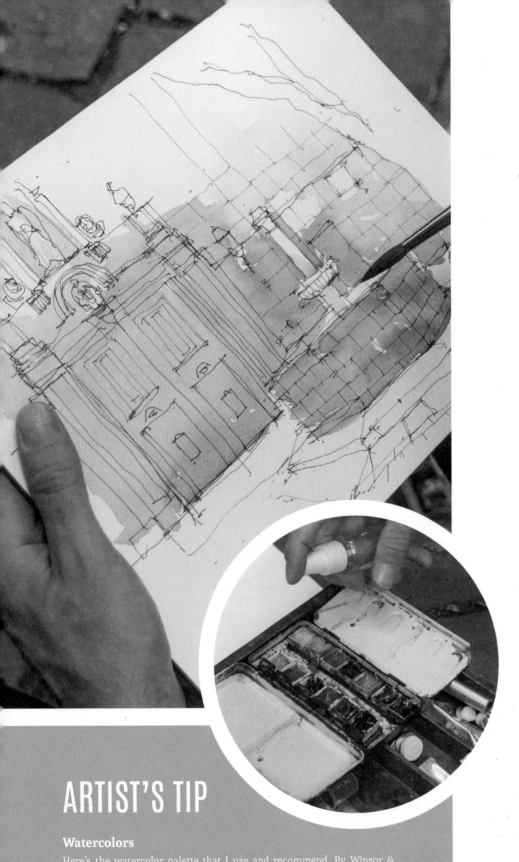

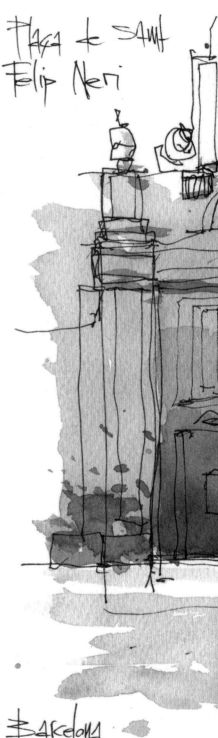

Plaça de Sant Felip Neri

Barcelona

ARTIST'S TIP

Watercolors

Here's the watercolor palette that I use and recommend. By Winsor & Newton, I use Cadmium Yellow, Cadmium Orange, Cadmium Red, Alizarin Crimson, Burnt Umber, Yellow Ochre, Burnt Sienna, Cerulean Blue, Ultramarine Green Shade, Permanent Sap Green, Viridian, and Payne's Gray. I also use Cerulean Blue Hue and Phthalo Green by Schmincke.

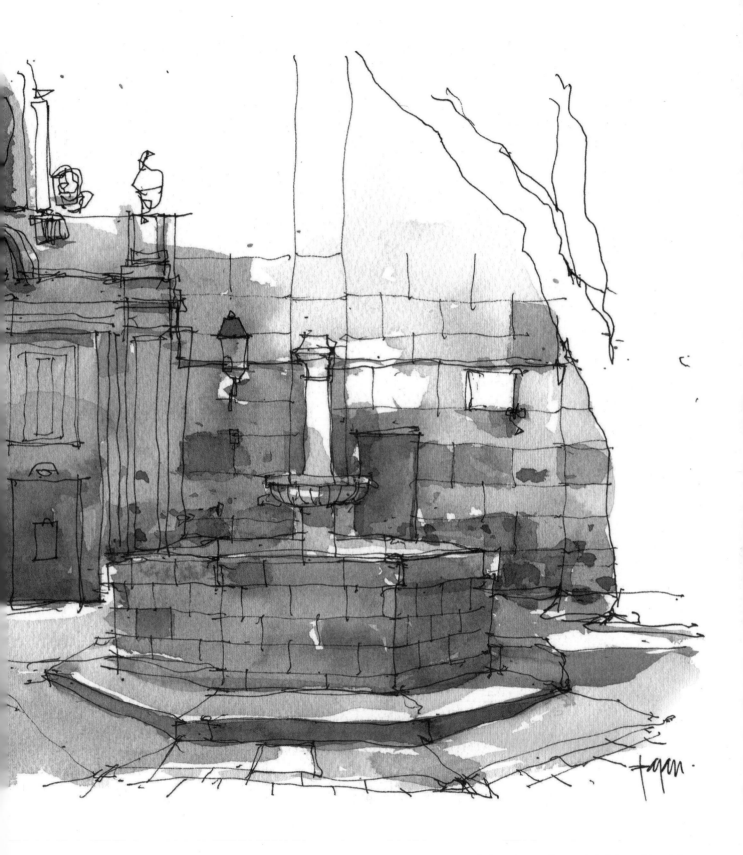

Top left: Adding more watercolor paint. It's interesting when the colors mix with each other on the paper instead of on a mixing palette

Above: The darkest layers of watercolor are added last. Final image © Daniel Pagans

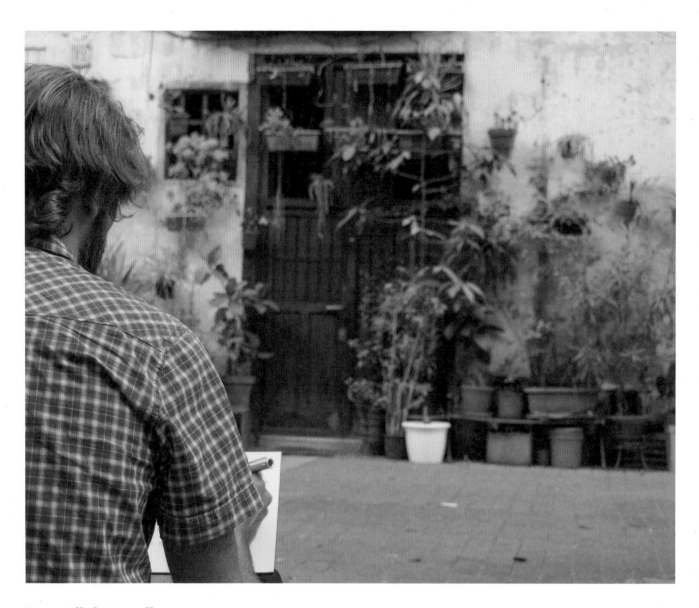

Carrer Allada Vermell

Allada Vermell is a square in Barcelona's neighborhood of El Born. It is situated between what used to be two streets; one called Allada, and the other Vermell. The two street names are now combined as the name of the plaza. Allada is recorded in Catalan literature as far back as the fifteenth century, and the name probably derives from "garlic fields" (the Catalan word for garlic is "all"). Vermell is a reddish color used in tanneries and also on the top of medicine tins which used to be sold here. After the Olympic Games in 1992, a row of houses was demolished between these two streets, opening up the area into a Venetian country-style plaza.

I love this place because it is always very alive and vibrant. There is one house in particular which always catches my attention: a unique house with many potted plants hanging on the front. It's like a garden oasis in the middle of the urban landscape.

Each time I visit this neighborhood I am drawn to this picturesque house that looks like it was born from an illustrated story. I was happy to have the opportunity to draw it.

This drawing took about twenty minutes to ink and thirty minutes to color, with a final fifteen minutes in the studio to add extra colors afterwards.

Above
Capturing the scene in pencil before starting to ink

Top right
Adding ink with a fountain pen

Bottom right
Adding watercolor after the ink has dried

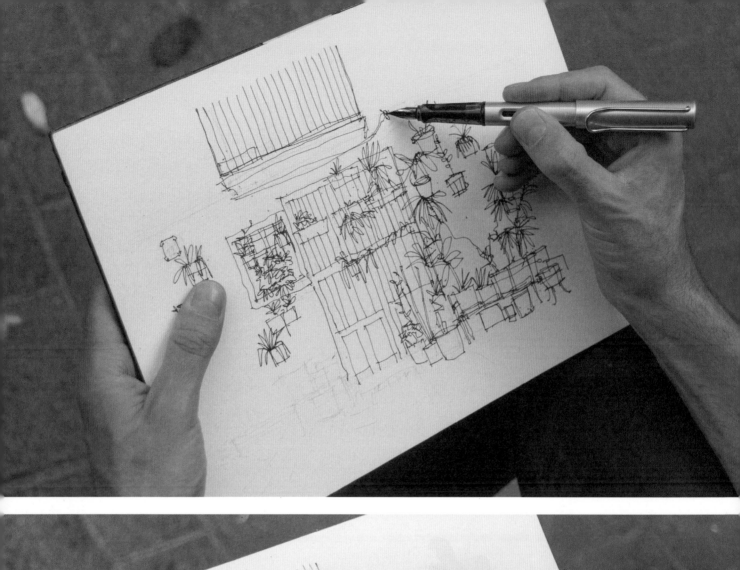
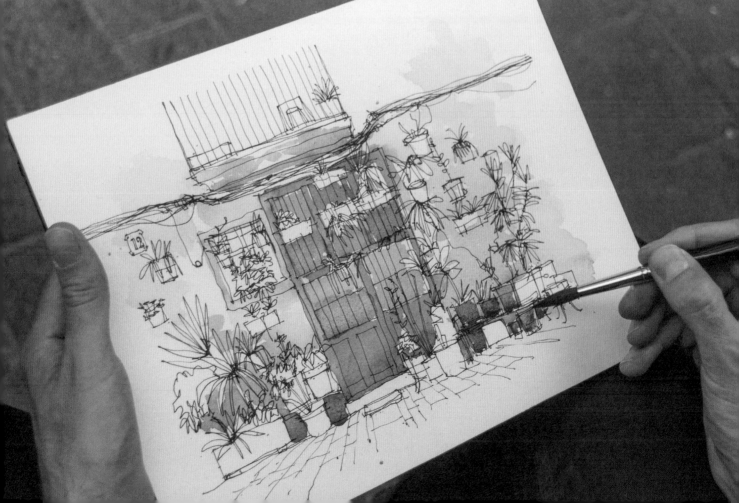

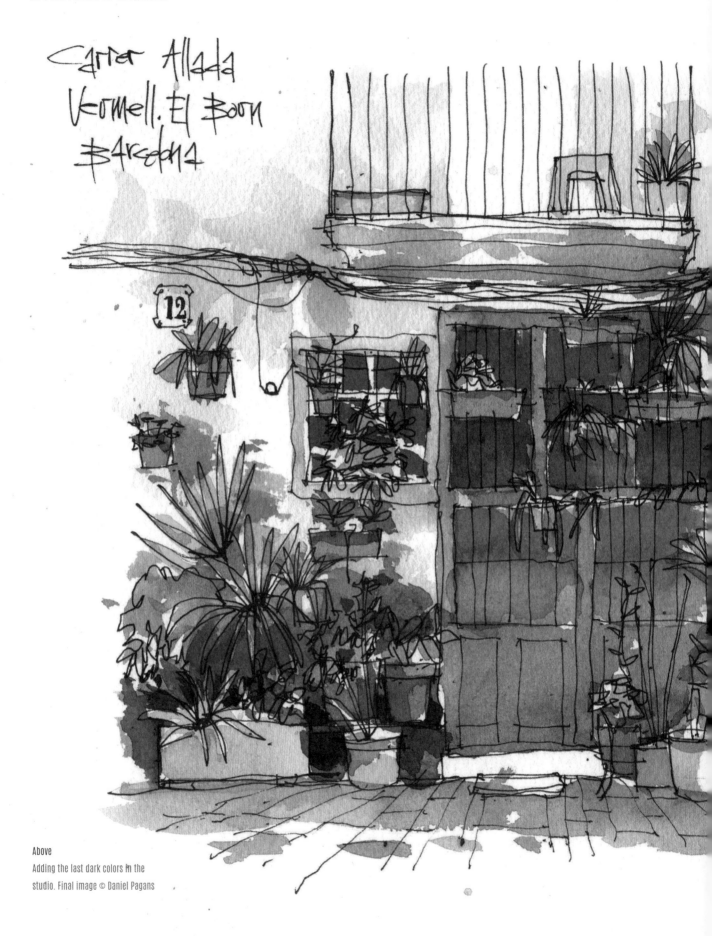

Carrer Allada
Vermell. El Born
Barcelona

Above
Adding the last dark colors in the
studio. Final image © Daniel Pagans

ARTIST'S TIP

Composition

Usually, to help settle on what composition I want to draw, I use my phone to take two or three pictures of the area. Having these photos can also be useful later if I want to add more details to the drawing when I get home.

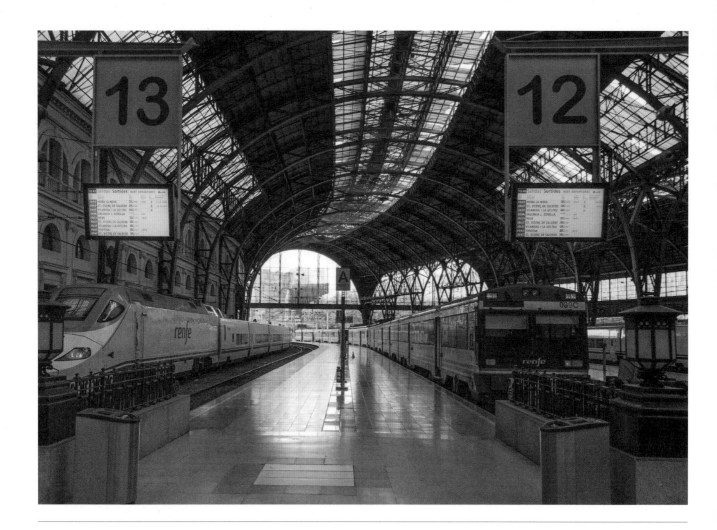

"For an urban sketcher, it is a perfect location when the weather is not very good"

Estació de França

Estació de França is a beautiful train station situated in Barcelona, often compared to the Gare d'Orsay in Paris. It was designed by the engineer Andreu Muntaner and architect Pedro Muguruza for the 1929 International Exhibition. They created a beautiful, modern train station which connected the first line from Barcelona to France.

It is composed of two main sections: the lobby and the train platforms. There are twelve tracks and seven platforms with a wrought iron ceiling allowing natural light to flow into the station from above. The lobby was designed by Duran Reynals and

has a beautiful ornate clock hanging on its wall. It is spacious and is used for a variety of activities including temporary markets selling vintage clothing and goods.

The materials used for the lobby and buildings around the track are marble and bronze, making the place look quite opulent. For an urban sketcher, it is a perfect location when the weather is not very good. It's great to sit inside and draw when it's a bit cold or getting dark outside, watching as people come and go on their travels.

This drawing took about five minutes to sketch and thirty-five minutes to paint.

Above
Photo of the location

Top right
Taking a few minutes to organize the composition

Bottom near right
Adding watercolor above the pencil lines. This is the first wash, applied to large areas of lights and darks

Bottom far right
Continuing with watercolor to fill the whole paper

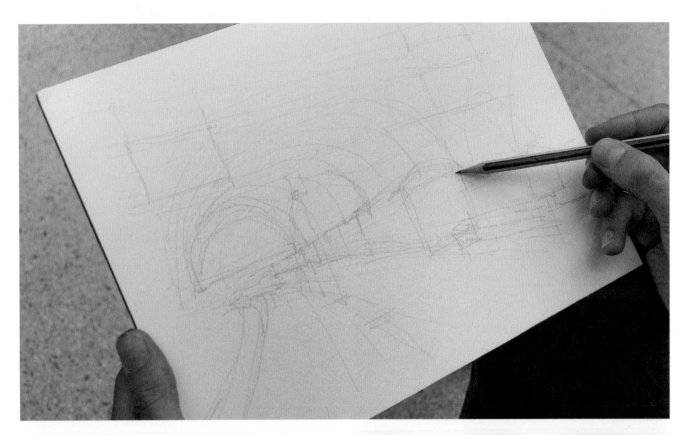

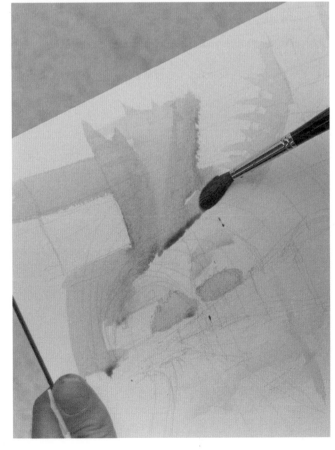

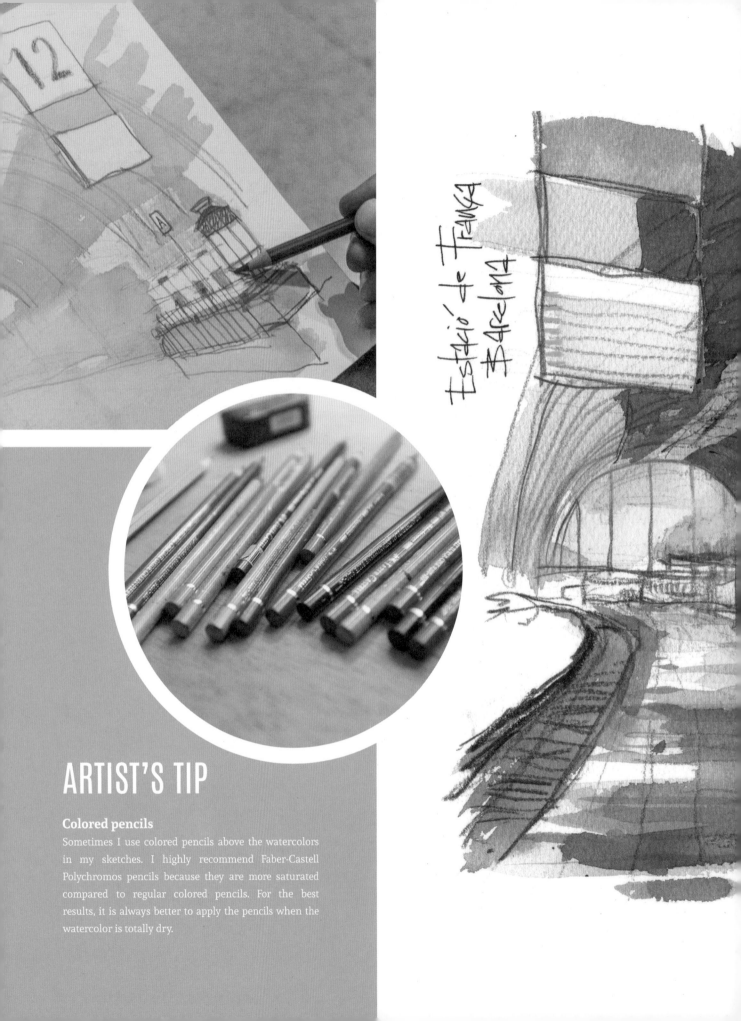

ARTIST'S TIP

Colored pencils

Sometimes I use colored pencils above the watercolors in my sketches. I highly recommend Faber-Castell Polychromos pencils because they are more saturated compared to regular colored pencils. For the best results, it is always better to apply the pencils when the watercolor is totally dry.

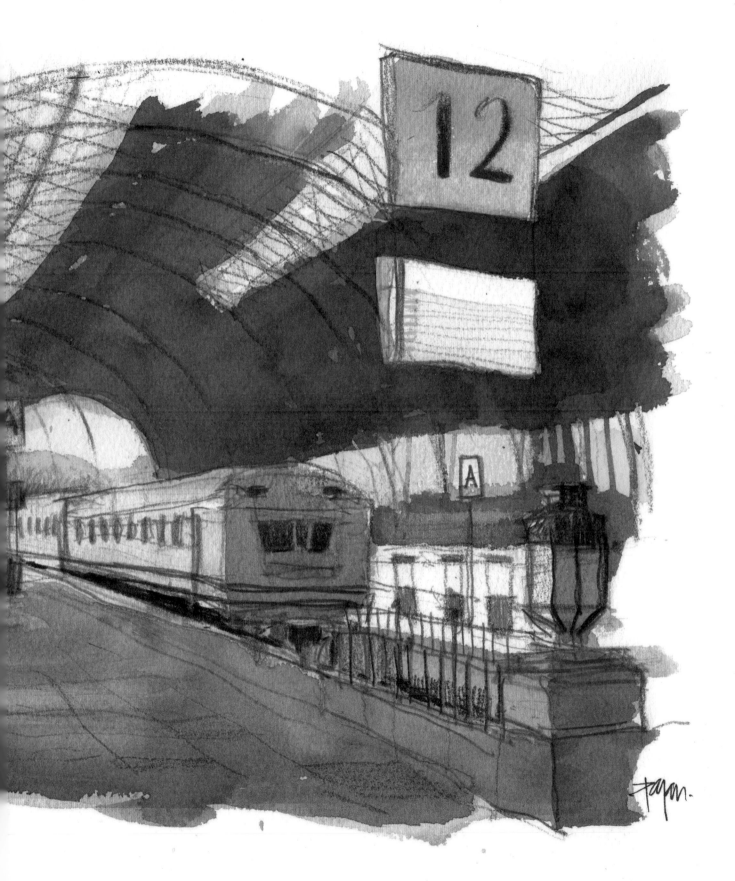

Above: Adding darks can create more volume. Final image © Daniel Pagans

LOOSE

A narrative illustration project with Anaïs Maamar | Story by Adam J. Smith

"It's bright in the rat room; strip lights illuminate from above and heatlamps glow from within each of the glass cages. The cages form a grid against the wall, a row of seven at the bottom and eight running up: fifty-six in total. Of course, up and down is relative in the space station. On the opposite wall the vast blue ocean shimmers majestically through the port window. Rats seem almost to swim on the surface; white rats with long tails that have escaped their cages, all the doors open. Rats floating, bouncing off walls or gnawing at cables that dangle from flashing instruments. The scientist in white chases, the coattail of her jacket trailing like a cape, one arm flailing and the other hugging fluffy white bundles to her chest."

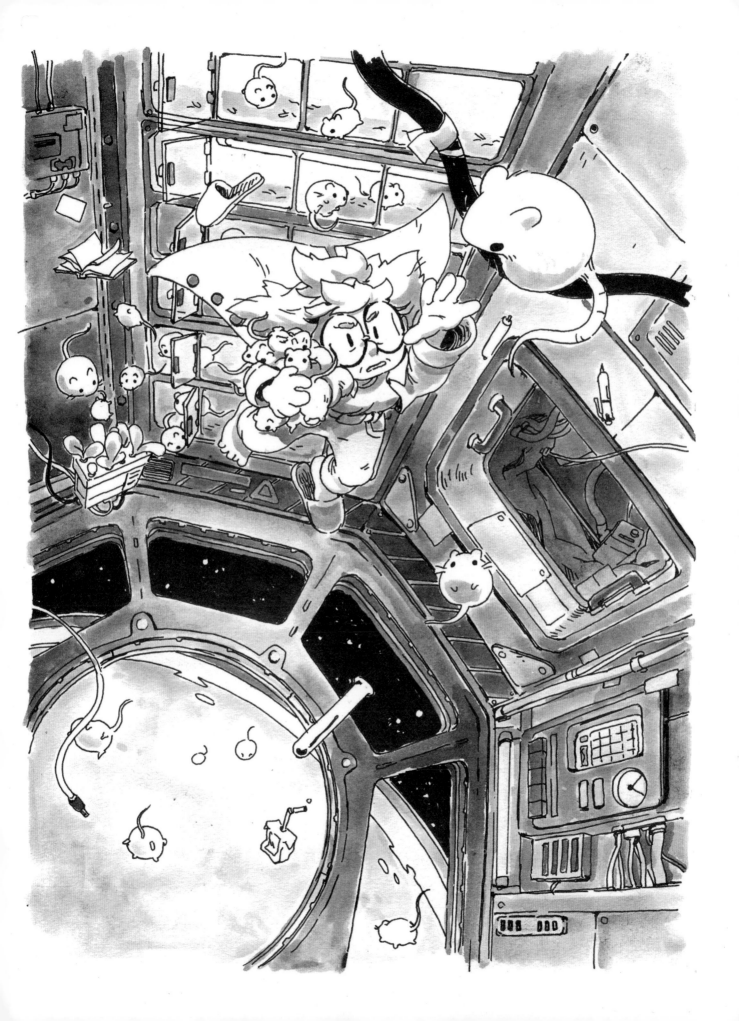

In this tutorial, Anaïs Maamar shows us how to sketch and ink a stylized space scene using pencils, brush pens, and water.

Left
The tools used for this illustration - also my favorite tools to work with most of the time

Top right
Thinking about the scientist's environment

Bottom right
Roughing out some composition ideas and thinking of a layout for the rat room

Drawing tools

I am a 2D artist based in Bordeaux, France, and currently work at the videogame studio Shiro Games. When I'm not making game assets and pixel art, I love to draw for myself and invent new characters or stories. My favorite things to draw are cute characters, robots, and sci-fi or urban scenes. Comics and animated series are what inspired me to draw when I was a child, and they are still what influences my work the most today. Experimenting with new ideas is my favorite thing to do: my sketchbook is the playground where I give life to what I imagine, and I fill it

with pencil sketches and ink illustrations like those you will see here. In this article I will show you my drawing process, from the early ideas to a final art piece in a comic style.

In the photo above you can see the materials I will use for this project. My favorite tools for sketching are a mechanical pencil, or sometimes a ballpoint pen. For inking, I prefer using my 0.35 mm Rotring pen and a Pentel reservoir brush for filling in black areas. In case I need to correct any details, I also have a Molotow acrylic paint marker to use as white-out. For research sketches, I will

use my sketchbook, which has a comfortable thick paper. For the final illustration, I will change to a separate piece of heavy paper, so that I can move it easily or replace it if I make a mistake.

Early ideas

As I am adapting a text, I think about the details in it which strike me the most. These will help me to choose the main aspects I want to represent in the illustration. I take notes and start making rough sketches of the ideas that come to mind, such as the layout and composition of the room and background.

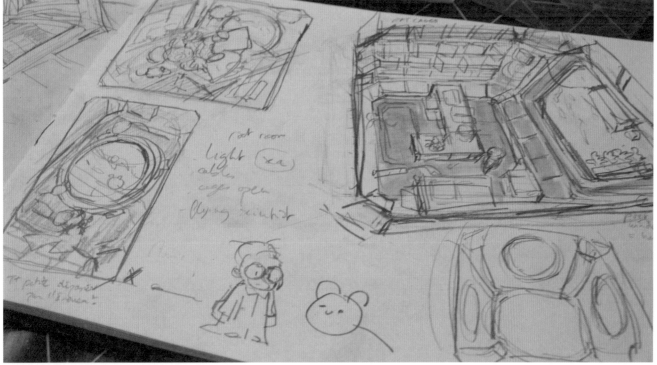

Rough sketches

The initial concepts appear like a rather common sci-fi setting: very high-tech, modern, and cold. I am not very fond of this ambience so I think of a way to make it more endearing, starting with the character. I imagine her as an elderly scientist who has been living on the space station for a long time, along with the fluffy white rats, to run her experiments.

Looking for reference

When there are a lot of elements in a picture that you are not used to drawing, it is useful to look for reference photos. These do not just show you how the objects are built, but can suggest things you would not have thought of on your own, opening the door to even more ideas. I look for reference photos of the inside of the International Space Station (ISS), and at concept art from sci-fi games and movies such as *Mass Effect* and *2001: A Space Odyssey*, and take note of the things that interest me the most.

Developing the setting

What I like about the ISS photos are the assembly of square shapes, and the wires and equipment floating around everywhere. There are also incredible photos of astronauts near a big circular window that I decide to use as a reference for the window of the rat room. I even research into how astronauts manage to grow vegetables in space, which could inspire some interesting details that give a hint about the daily life of our space scientist.

Creating personality

Now that I have a good idea of how the environment will look, I start thinking in more depth about what the main character might look like. This is usually where I have the most fun. I want the scientist to be a sympathetic "grandma" character, so I use mostly gentle, round shapes. I make her jacket too long, as if she has been wearing the same one for a long time despite getting shorter with age.

The rats

After looking into several different ways to make an interesting design for the rats, I decide to go with the simple ball-shaped design from my early sketches, as it's the one I find the most fun to look at. Simple ideas often work the best. There will be many of these rats in the picture, so a design with too much detail would risk overloading the image, while being tedious to draw.

Near right: Rough sketches inspired by photos of the inside of a space station, and of objects from the scientist's daily life

Far top right: A moment in the scientist's everyday life in her environment: checking how her rats are doing before going to bed

Middle right: Working out the attitude and clothes of the scientist

Far bottom right: Flying fluff-balls in various shapes!

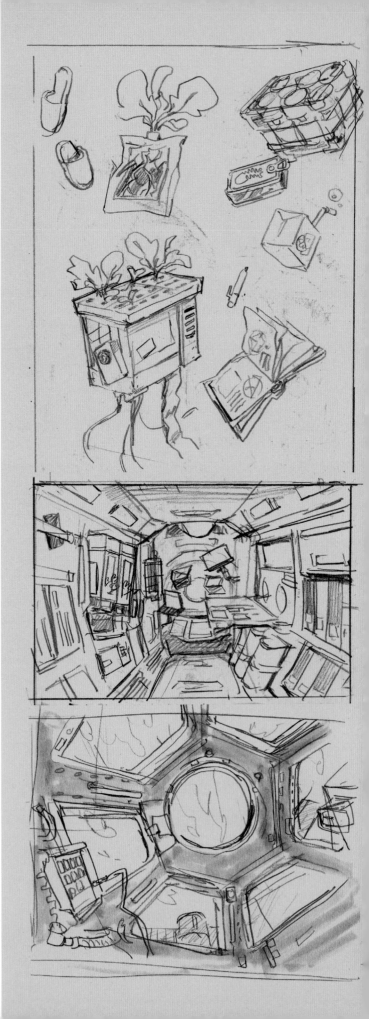

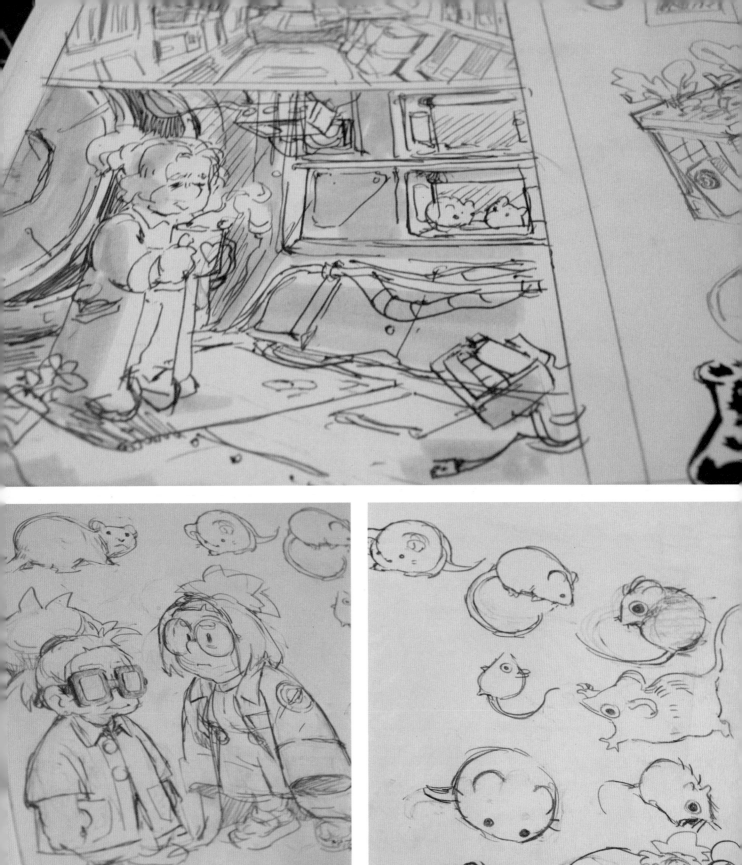
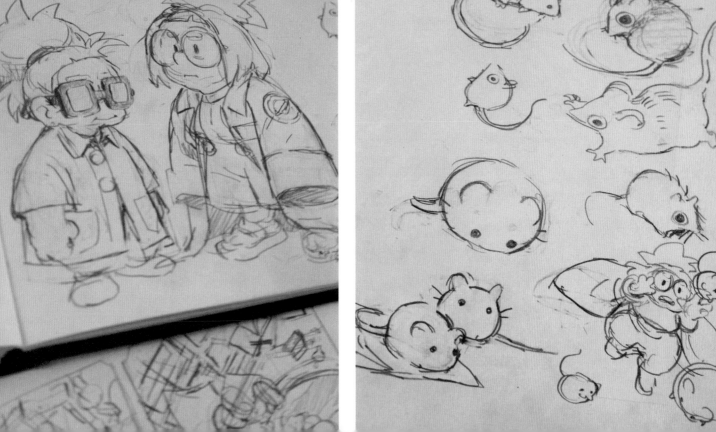

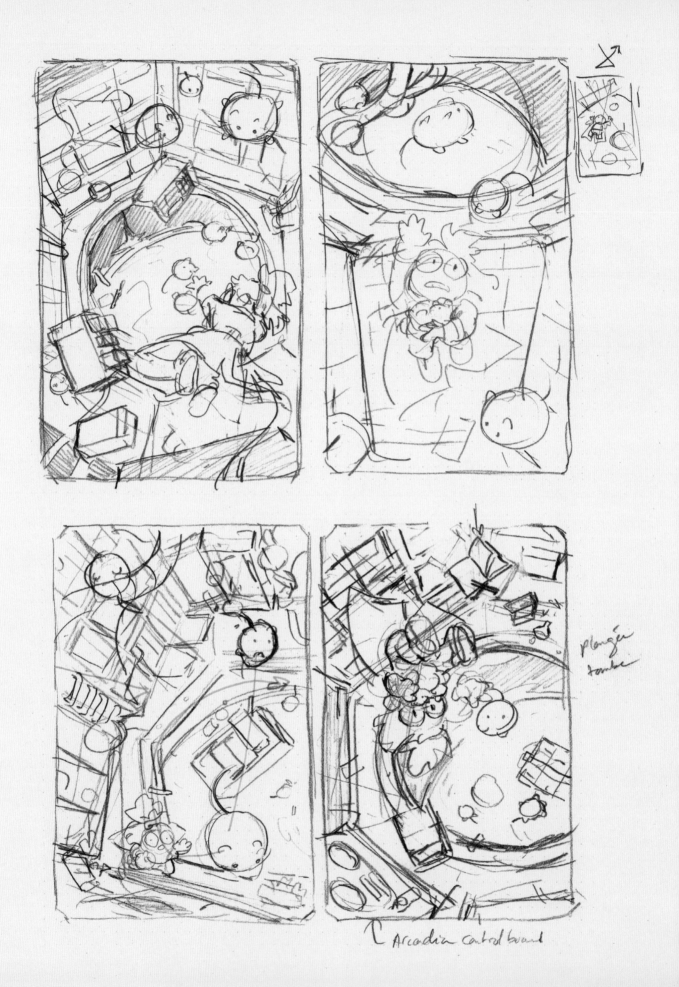

Arcadia control board

"I want to suggest the mess caused by the escape of the rats, the exasperation of the scientist struggling alone in weightlessness to catch them, and the vertigo of a setting that has no up or down"

Far left
Different composition ideas

Near left
The final composition

Composition

Now that I have worked out most of the visual elements of the picture, it's time to think about the composition. I sketch out several ideas in a small format. I want to suggest the mess caused by the escape of the rats, the exasperation of the scientist struggling alone in weightlessness to catch them, and the vertigo of a setting that has no up or down. Using a high angle view will be a good way to show this feeling. I want the window to have an important place in the image as well, as the rats seeming to "swim" in the water seen through the window is a very powerful image given by the text.

Final composition

Finally I choose the composition in which the scientist reaches towards the top of the image to catch a rat that's clinging to a cable. I choose this because it's the composition in which the intention of the character is the most readable, with strong lines of action that guide the viewer's eye on a clear path through the image, and the different parts of the background are better organized.

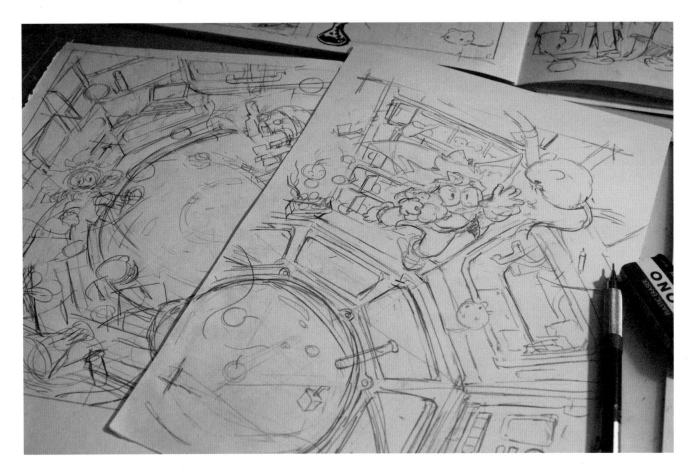

Final sketch

Now that I have decided on my illustration layout, I copy it at full size onto a piece of A4 paper. I mirror the scene as I do so, as I feel that it is more natural to "read" the composition when it's flipped the other way around. It is important to take the time to place everything correctly before starting the inking process, so even though this is still a rough pencil drawing, I rework it until I feel satisfied with it.

Light table

In order to ink over my rough sketch safely, I like to use a light table. This way, instead of inking directly on the rough sketch and losing it if I make a mistake, I can keep the sketch intact and make as many inking attempts as I need to until I am satisfied with the result. To ink this picture, I will use my 0.35 mm Rotring pen, which I like for its regular line and the control and fluidity it gives compared to other fineliner pens.

Inking process

I start by inking the parts of the picture that are in the foreground. This way there will be no problems with incorrectly overlapping lines when I start to draw the background. Inking can be quite a painstaking process that requires a lot of concentration. One mistake can be enough to spoil the whole drawing. To me, it's the most challenging part of making an illustration!

Adding blacks

When the lines are finished, I can start to add values and shading to the drawing. I start with black, as it will be a benchmark for all the lighter gray tones I will add later. For flat black zones, I use my refillable Pentel brush pen, which I like as it combines the precision of a pencil with the natural effect of a paintbrush. I want to keep little spots of white in the flat blackness of space, suggesting stars in the distance, so I intentionally leave some of the white paper visible.

Above
The layout is complete.
Now, on to the inking!

Top right
Keeping the rough sketch separate from the clean illustration can be a life-saver if I make a mistake!

Near bottom right
The completed line work, after an hour of sweating and suspense

Far bottom right
The dark, endless void of space behind the window

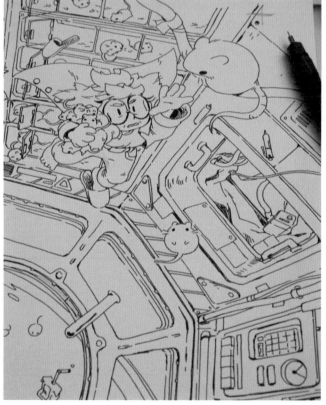

Grayscale shading

Adding gray tones will help make the focal areas of the image pop, as well as give a sense of lighting. I use the same ink that I used in the Pentel brush pen, but diluted in a mixing palette with a waterbrush. I start with lighter tones and then add darker layers if needed, to make sure that I do not add a gray that's too dark without realizing too late. To help highlight the character and escaping rats, I keep them white to create contrast with the darker gray background.

Final details

To the right, you can see how I have added some light shadows to the characters as if they are lit by a bright neon from the ceiling, which also creates areas of subtle detail, leading the viewer's eye to the main character more easily. With a few last adjustments to the background grays, our space adventure is finally complete.

ARTIST'S TIP

Try new things

If you are a beginner, don't be afraid to try new things. It takes a lot of time to build your own artistic personality, which will constantly evolve as you discover new things throughout your life. Stagnating is the worst thing for your creativity, and you cannot improve without getting out of your comfort zone, testing new techniques, trying out other styles that you like, and sketching subjects that you are not used to.

When having an "art block" or feeling bored, opening your mind can be a great way to discover new potentials and learn things that will make you look at your work with a new eye. There is no "right way" to make art, so just be curious, pursue what you like, and experiment with it. Make mistakes and learn from them. It doesn't matter if it looks good or bad in the end – the most important thing is to learn and have fun. From this point, you can only get better.

Above
Painting the gray tones with diluted ink - the most relaxing part of the inking process

Right
The final illustration © Anaïs Maamar

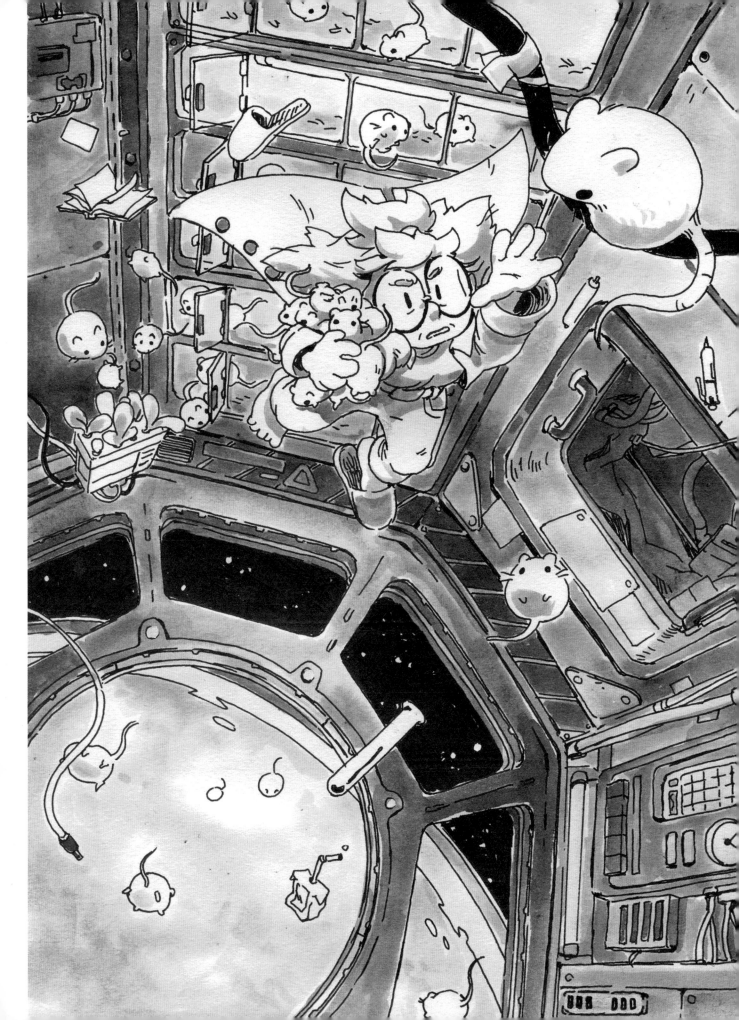

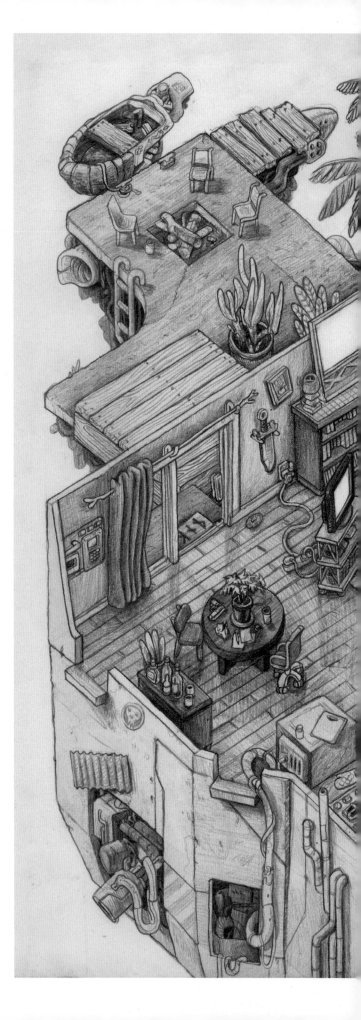

THE
GALLERY

Featured artists:

Jarrod Goldman

Geizi Guevara

Vasilisa Koverzneva

Yuriy Skorohod

Basia Tran

Jason A. Mowry

Wojciech Piwowarczyk

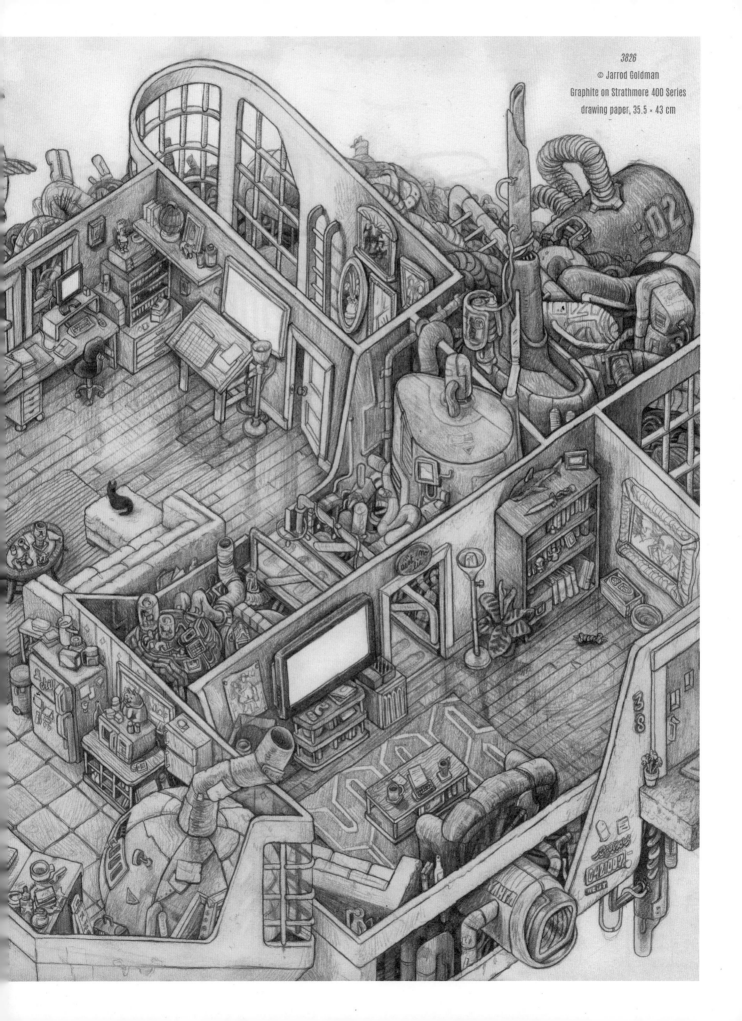

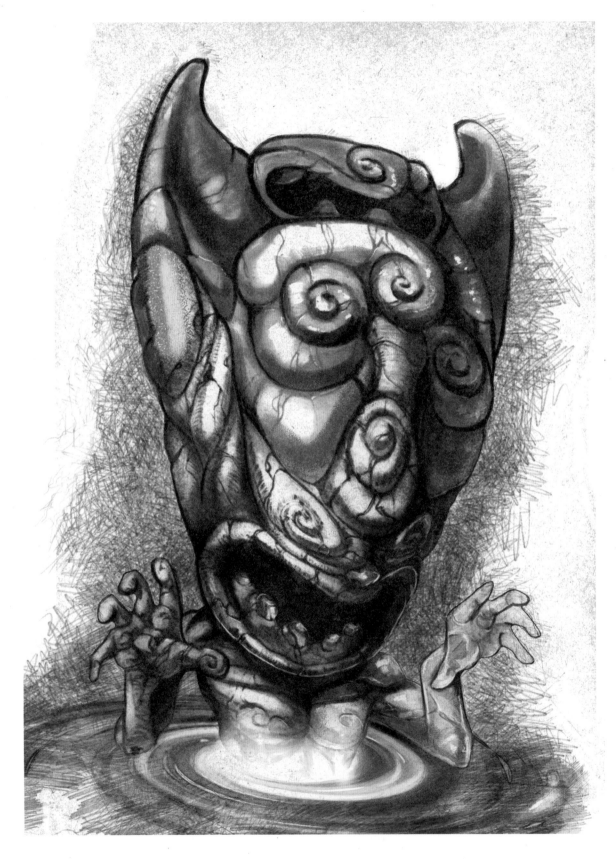

Mascaras © GGkoncepts (Geizi Guevara) • Pencil, thinner, and Adobe Photoshop

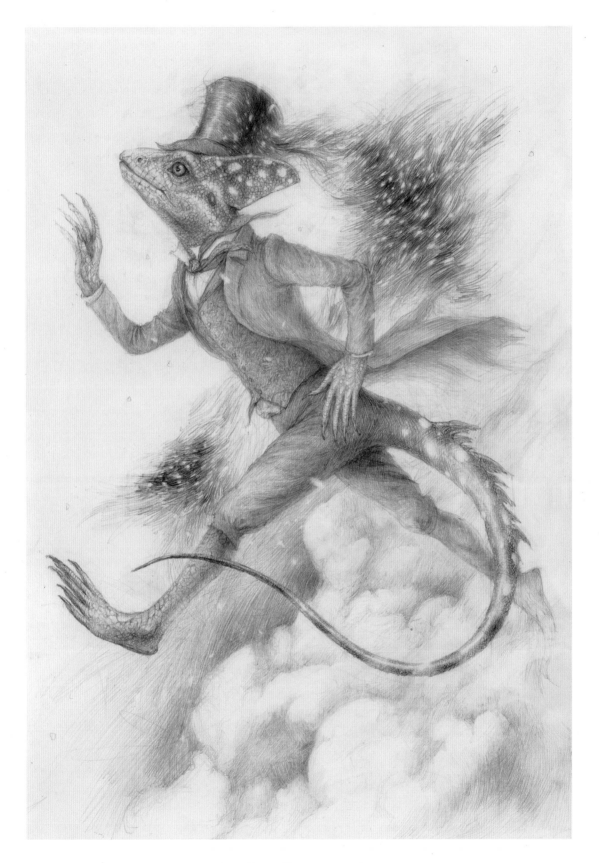

Running Basilisk © Vasilisa Koverzneva • Pencil on paper

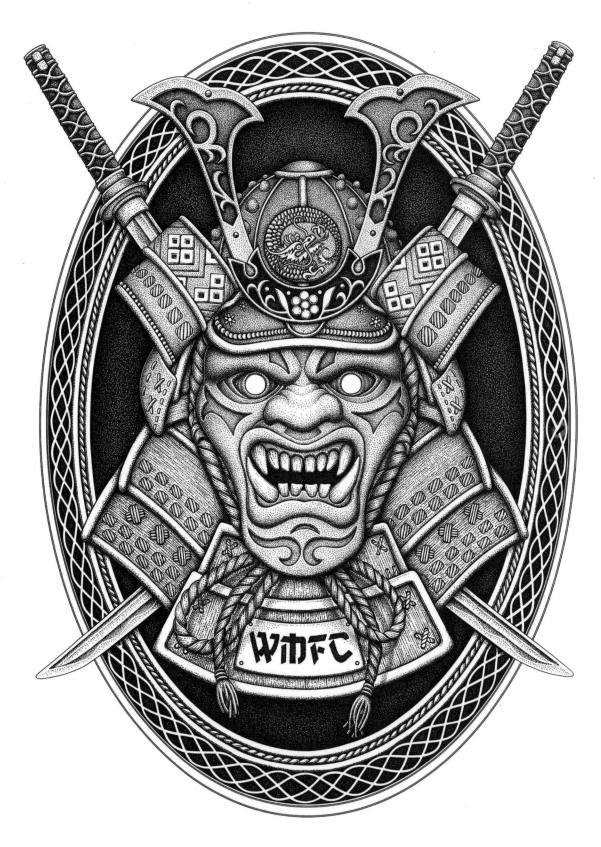

Mempo © artsc0re (Yuriy Skorohod) • Faber-Castell Rapidograph pens on A4 300 gsm photographic paper

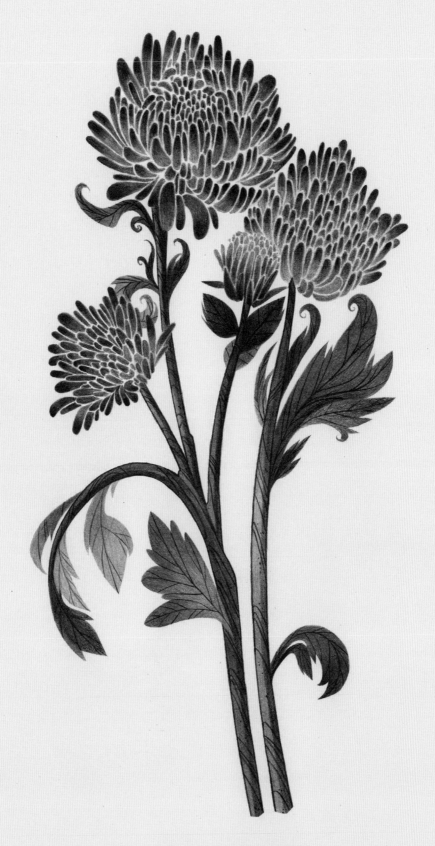

Chrysanthemum © Basia Tran • Graphite

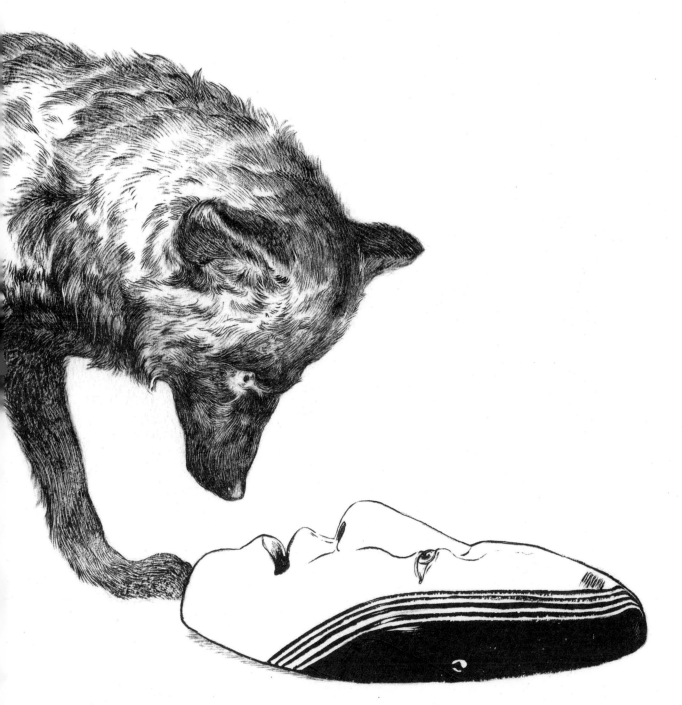

J MOWRY

Tree study
© Wojciech Piwowarczyk
Fountain pen and gray liquid
watercolor, 45 × 50 cm

THE GALLERY CONTRIBUTORS

 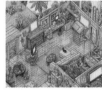

Jarrod Goldman is from Pensacola, Florida, and graduated from the University of West Florida with a BFA in drawing/painting. *3826* depicts Jarrod's current house, layered in science fiction and fantasy details, in a cutaway isometric style inspired by a passion for videogames.

jarrodgoldman.com

Geizi Guevara is a multi-disciplinary designer and illustrator currently based in Los Angeles, California. Geizi works with an eclectic mix of mediums, styles, and aesthetics, and over the years has built up skills ranging from graphic design and typography to 3D and web design.

ggkoncepts.com

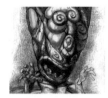

Vasilisa Koverzneva is a professional artist based in Russia. She is inspired by rock music, movies, books, and animals, and likes to see the magic in little things. Her work mainly uses watercolor and ink, aiming to achieve subtle color transitions and layered compositions.

instagram.com/vasilisk_art

Yuriy Skorohod is a graphic artist based in Minsk, Belarus. He graduated from the Belarussian State University in 2009 and has spent the past few years working in pointillism. *Mempo* is the term for various facial armor worn by samurai and their retainers in feudal Japan.

artscore.by

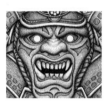

 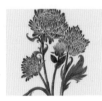

Basia Tran is an illustrator from Cracow, Poland, currently based in Brooklyn. During the day she works as a concept artist for Roof Studio. During the night she explores more whimsical worlds through her personal work, where her interest lies in the fantastical.

basiatran.com

Jason A. Mowry grew up between art museums and comic book shops, combining the rhythms of each to walk the line between formal art and the bold fantastic. He calls Columbus, Ohio home, and has spent the last two years illustrating over fifty of Aesop's stories.

jasonmowryart.com

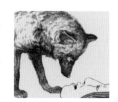

Wojciech Piwowarczyk is an environment artist currently working at Axis Studios. Professionally he creates 3D environments for games and film, but his background is in fine art and he still draws and paints in his spare time. He never leaves home without a sketchbook.

wojciechpiwowarczyk.artstation.com

DRAWING FROM LIFE

Observational sketching techniques with Dwayne Bell

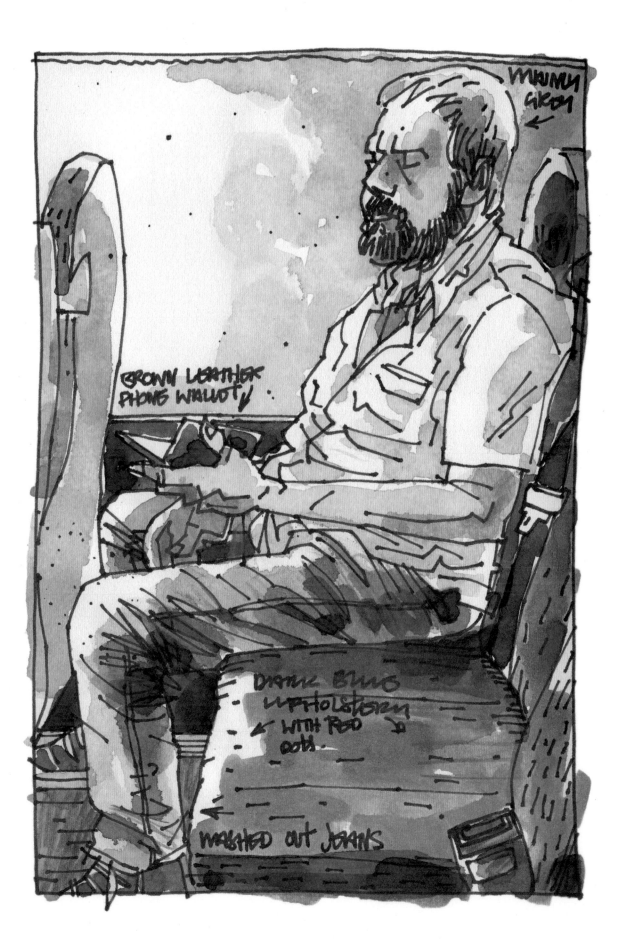

In this article, illustrator and lecturer Dwayne Bell shares some tips and techniques for improving your sketchbook use and capturing on-the-go studies with pen and watercolor.

Left
An A6 sketchbook and pen fits easily in your pocket

Near top right
A fountain pen with a bold nib and slightly watered-down ink encourages bold and simple line choices

Far top right
One of my favorite drawings from the exercise. I enjoy the fluidity of the lines, as well as that hat! Final image © Dwayne Bell

Bottom right
I reduce this complex subject to a series of simplified shapes. Final image © Dwayne Bell

I lecture in illustration at the University of Cumbria and commute to work from my home in Scotland on a daily basis. Over the last several years I have been using my commute time to draw my fellow bus passengers, filling many, many sketchbooks with observational portraits.

My working method has developed over those years, and I now utilize a simple toolkit (a sketchbook and pen for the majority of work) which I prefer to an extensive and complex set of tools, and which is also much more suited to working on busy public transport.

As well as on the bus, I enjoy drawing anywhere I can find people, whether it be in a meeting at work, in town doing some shopping, or enjoying a coffee in the local café. I am always looking out for an interesting face, unusual detail, or someone who simply looks like they're not going to move too much. In my opinion, age and character beat youth and beauty, as a drawing subject, every time. I do not spend too long on most drawings, preferring an economical use of line, trying to capture as much as I can, simply and quickly. Given that the majority of my subjects are likely to move at any moment, this approach is very important.

These tutorials will cover some of my practical and theoretical approaches to drawing the people you may encounter on any given day.

Quick A6 studies

This first piece of advice is not formed around a single image but rather an approach to creating a collection of drawings. Many artists like to have several major sketchbooks on the go at one time, but I prefer to have one main A5 Leuchtturm1917 sketchbook. I sometimes find I am becoming too uptight and precious with it, worried about ruining a page and disrupting a series of successful drawings, or unwilling to fill too much of it with rough work.

A good sketchbook can cost £20 or more, so why would I want to have bad drawings in it or to fill it too quickly? Then again, it *is* a sketchbook, so it should be used for practice, and as a place to learn!

To help myself loosen up and approach drawing without these worries, I sometimes buy additional, cheap A6 pocket sketchbooks that I fill with quick and playful observations. I can fill one of these books in a couple of hours, or I might just fill a couple of pages before returning to my main A5 book. In these sketchbooks, I do not feel committed to producing "good" work. The drawings are

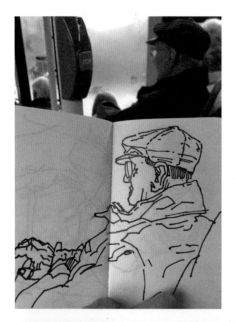

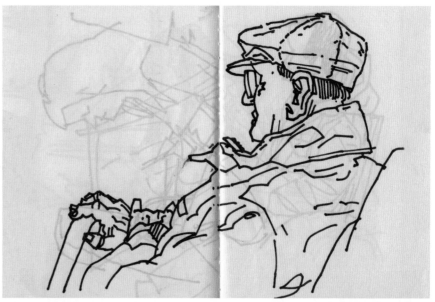

created without concern for the outcome, but no matter how rough or odd they are, I often find them to be among the most enjoyable to look back upon and to learn from. This is where I discover concise ways of capturing particular elements, such as hands, profiles, and clothing. Stick an A6 sketchbook in your pocket, along with a pen, and you have everything you need to begin drawing.

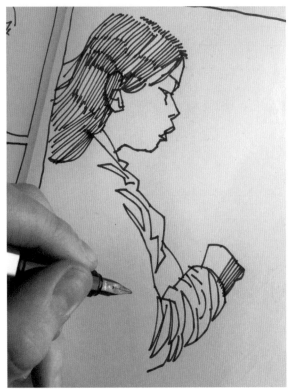

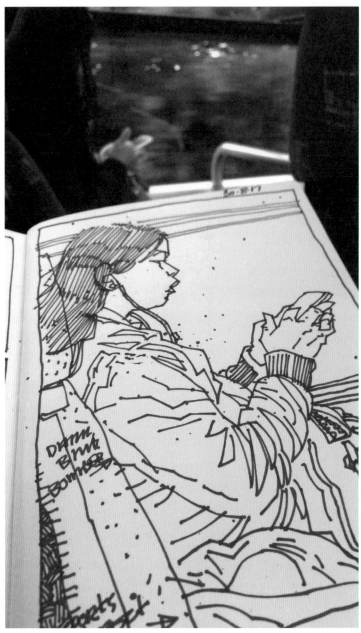

Sketching on a commute

I spend about eight hours a week on public transport, and I like to use as much of that time as I can to draw. Here I have captured the process of a simple "bus drawing" of a fellow passenger. The process begins before I take my seat, as I look for a passenger I can sit opposite and slightly behind, who also seems likely to sit quite still.

I begin by drawing a frame on the page to help me compose the sketch. I consider my subject and visualize her silhouette on the page. I then quickly draw her profile; if I take too long and over-think details, I produce less successful work.

The profile fixes the drawing on the page and every subsequent detail relates to this initial position. It's tempting to start again if you are less than delighted with your result, but I would encourage you to see each drawing through to its conclusion, and just have fun with it.

I enjoy playing with details such as creases in clothing and, in particular, the challenge of hands. The fact that my subject is using a phone is ideal, and I make a point of including this fact as it brings a sense of narrative to the image.

I finish the sketch by adding more textures, creases, and details to the drawing, which help control the page's negative space. I also often note down key colors, so that if I choose to, I can add paint later.

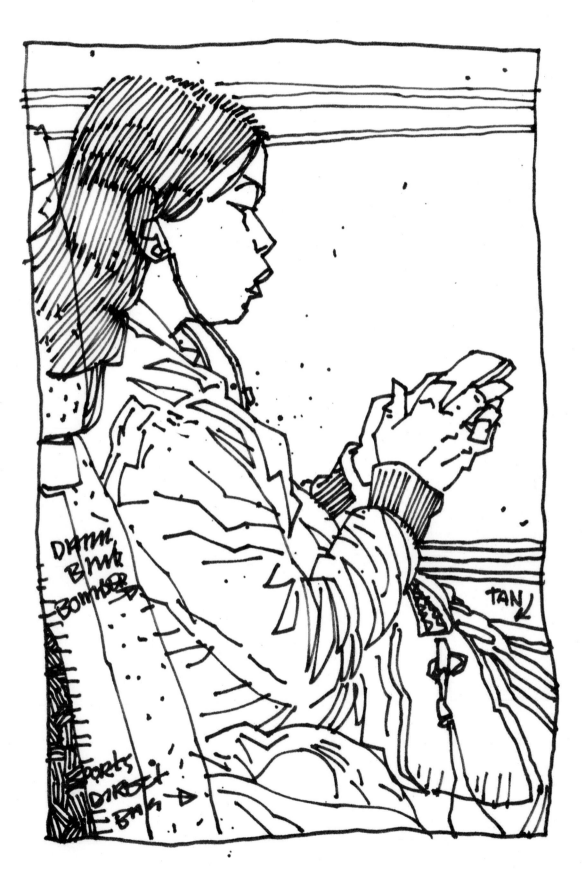

Far top left
I begin with decisive, confident marks describing my subject's profile. These anchor the rest of the drawing

Far bottom left
I have some fun drawing folds and creases in the clothing and, in this case, use minimal lines

Near left
The clothes and bag help to populate the drawing. With practice you will start to spot the potential in these details

Right
The lines of the final drawing work to create an almost abstract pattern that fills the page. Final image © Dwayne Bell

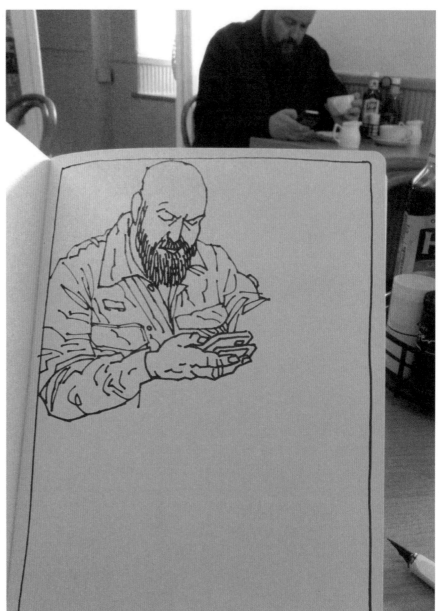

Greasy spoon

Working with simple materials – an A5 sketchbook and a pen – allows me to draw without fuss in most places. Like many artists, I enjoy trying new materials, but I know I can have the most fun with just these two items. Keep your regular toolkit simple and get into the habit of always having it with you so that you do not miss any opportunities to draw.

In this case, I am sketching in a "greasy spoon" diner. This drawing follows my usual approach. First I add a frame and visualize my subject on the page, getting an idea of scale and position. I start with the face and head, being sure to not over-work or add too much detail. From there I draw quickly, keeping my lines concise, describing as much as possible with each. This takes practice but is worth the effort – it allows me to capture my subject quickly, as well as adding a gestural quality to my lines.

Your subject's "props" should not be ignored, as they help to provide viewers with some context. You do not have to include everything, but a coffee cup or mobile phone is the difference between someone living a life and someone just floating on your page. The sauces on the café table are too good to ignore, so they are included here too.

When working quickly from life, you may find that you misjudge the drawing's scale on the page. For example, my subject's feet do not fit on this page, so I add them to a piece of paper which is taped on later. Do not be afraid of "low-tech" approaches like this – you're working in a sketchbook, after all.

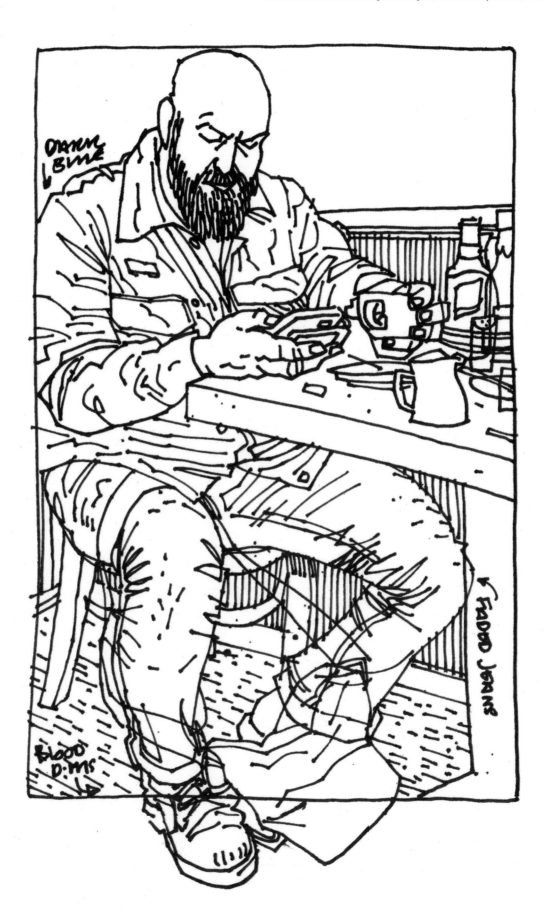

Far top left
I start with the head and face. Not only does this anchor the image, but it dictates the drawing's tone

Far bottom left
Keeping lines concise and drawing directly with pen means you can work quickly and capture the basics in no time

Near left
People on their phones make good models, as they sit still and are not hard to find!

Right
The subject's foot breaks the frame but becomes a positive feature of the finished sketch. Final image © Dwayne Bell

Another bus texter

For this drawing, created as per the others, I decide to add paint when I get off the bus. I utilize the key colors that I have noted down, and some other colors which I am happy to make up. (Who's going to know?)

I do not have a photographic memory, and my aim in these pieces is not realism or high levels of detail, but rather to add interesting and expressive textures to my drawing, the color of which should add visual contrast to an otherwise predominantly monochrome sketchbook. It is not necessary to be a technically very good painter to do this.

I find that if I am too careful with my application of paint, I end up with a piece that looks too "colored in," but if I paint as I draw – expressively and playfully – the outcome is far more successful. I like to let the paint go over the lines and sit in blobs, and I like to leave plenty of white (particularly around outer edges, where it gives the impression of light behind my subject). Be sure to allow colors to dry before you add others on top, unless you want a bleeding effect.

Once the watercolor washes have dried, I like to use some crayons or colored pencils to pick out a few highlights and add further textures. Here I use a Pentel Multi 8 (eight colored crayons in one handy mechanical pencil) and am quite minimal in picking out a few spots to add extra color to.

Near top right: Part of the fun of watercolor is creating your own palette of colors. Mine has far too many blues!

Near middle right: I have fun with my paint, keeping it loose and expressive, rather than simply "coloring in"

Near bottom right: Leaving white areas helps to give a sense of light while adding texture to your piece

Far top right: I often use colored pencils to add extra detail once the watercolor has dried

Far bottom right: The sense of light and form help to bring this drawing to life. Final image © Dwayne Bell

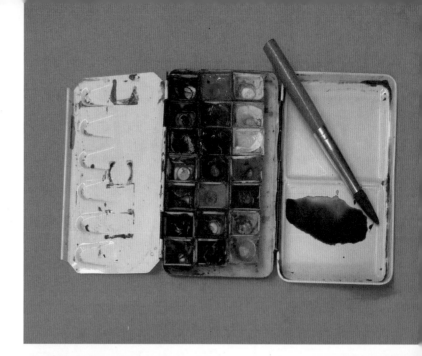

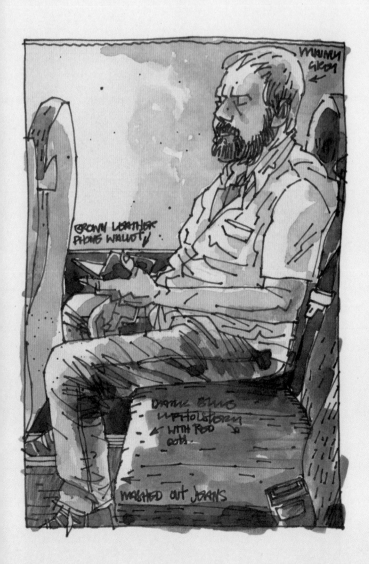

BROWN LEATHER
PHONE WALLET

DARK BLUE
UPHOLSTERY
WITH RED
DOTS

WASHED OUT JEANS

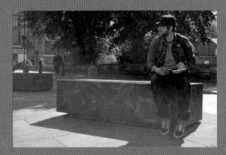

ARTIST'S TIPS

Mouthwash hack

One of the difficulties of traveling with watercolors is the need for a fresh supply of clean water. You can take as many jars and collapsing containers as you want, but once you plop your brush in, your water is dirty, and your colors are muddied. Try buying a bottle of children's mouthwash, the type with a little cup on top that fills when you squeeze the bottle. Empty the bottle and fill it with water. When you squeeze it, you will have clean water to paint with. When that water is dirty, just pour it out, and squeeze again.

Make mistakes

It is tempting to scrap a drawing when you think it's not working, or when you make a "mistake," but stick with it. Before you start, accept that mistakes are going to happen, and don't worry when they do. Have fun with whatever lands on your page and you will find yourself pleasantly surprised. When looking over old sketchbooks, I often enjoy the "bad" and mistake-riddled drawings the most.

New materials

Do not expect to produce great results with new materials. I see a lot of students spending money on new pens, paints, sketchbooks, and other materials, only to give up on them because they could not get the results they wanted straight away. Accept that before your new pen, pencil, or brush feels like an extension of yourself, you are going to fill a lot of pages and be frustrated with the results. Rather than thinking of this as a problem, think of it as part of the fun.

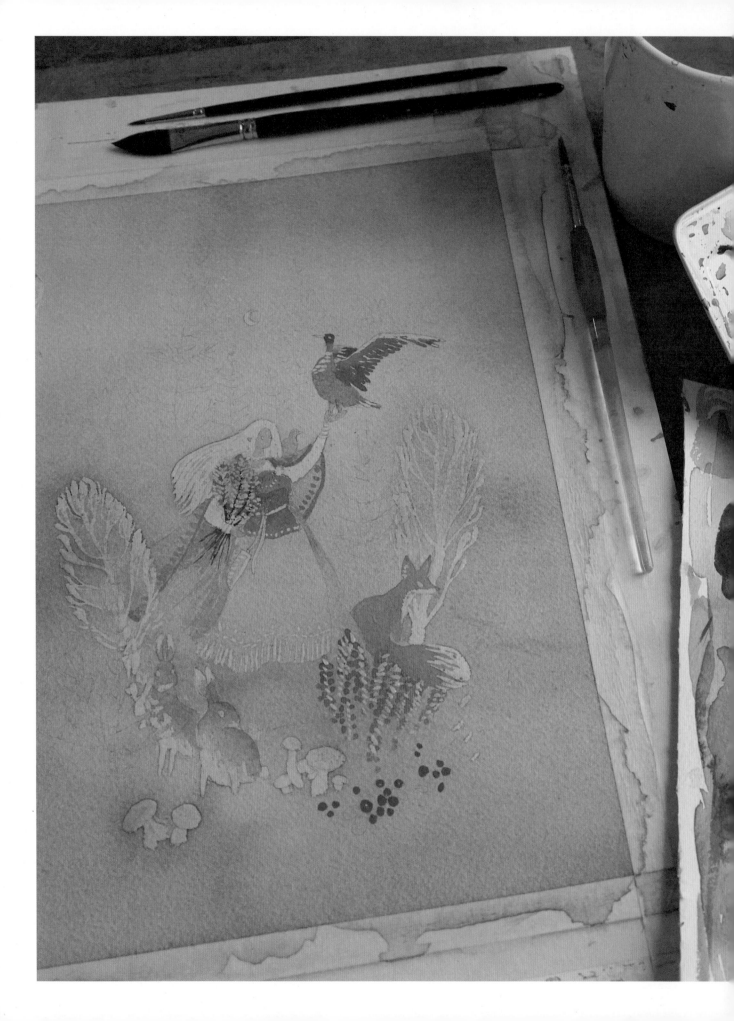

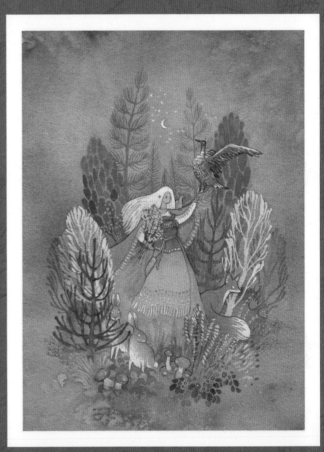

MIELIKKI

Illustrating in watercolor with Ulla Thynell

Join illustrator Ulla Thynell in creating a dreamy painting based on Finnish folklore, using pen, watercolors, and masking fluid.

The subject

All illustration begins with knowing your subject. The theme for my illustration comes from Mielikki, a goddess of forests and the hunt from Finnish folklore. She is in charge of the woodland, its animals, and healing powers. Early Finns tried to gain good luck for hunting small animals or finding berries and mushrooms by praising Mielikki's beauty with flattering rhymes. She also appears in the Finnish national epic *The Kalevala*, which is based on Karelian folklore.

This tutorial will delve into the creation of a watercolor illustration of Mielikki. Different stages of the creative process will be covered, such as subject research, designing the composition and color scheme, and using a selection of traditional illustration techniques. The image will be gradually transformed from a rough pencil sketch to a full-fledged painting with Pigma ink pens, masking fluid, and watercolors.

Research

It is useful to study your subject from various sources, such as books and online articles, or by interviewing someone who is an expert on that topic.

In addition to reading and examining iconic artworks about Finnish mythology, I also carry out some research on a few related topics, such as traditional Finnish costumes, which will offer inspiration when designing details for my illustration.

Ideation

As I research, I take notes and write down the ideas as they emerge. At this point it's good to play with a few alternative ideas before settling on a single one. After drawing some rough thumbnails, I decide on a harmonious scene with Mielikki playing the part of the ethereal lady of the forest, with traditional-styled attire and a bouquet of heather in her arms, surrounded by the smaller animals of the forest.

Far left
The artist at work!

Near left
My workspace

Top right
The creative process starts
with researching the
subject, taking notes, and
sketching the initial ideas

Bottom right
Sketching is done
with pencil in a
regular sketchbook

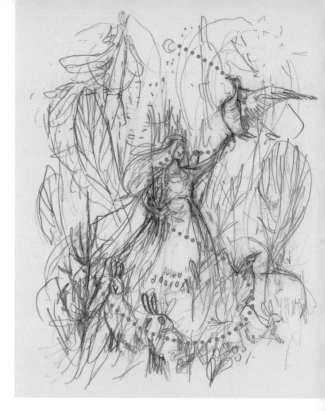

Composition

The first sketch is rough and messy. Like intuitive thinking but on paper, I search for lines that enlivens the idea. Shapes build up gradually, starting with tentative lines, which I then amplify, erase, or redraw. Mistakes and clutter are part of my creative process. The messy elements are mere placeholders – the most essential point at this stage is the composition. I look at the proportions of the whole scene, paying attention to the directions of the main lines and the locations of "hot spots" to which the viewer's focus is easily drawn, providing an interesting and natural movement for the eye.

Detailed sketching

Next I scan the rough sketch, increase the lightness digitally and print it out on regular copy paper, scaled to the final size. I continue with a technical pencil and draw a more refined, detailed version directly on the print, guided by the lighter lines. At this point it is still easy to modify things: I test a few combinations of different animals around Mielikki, before settling on the final version and proceeding to refine the details.

Narrative

While the drawing process may sometimes be intuitive, I also recommend reflecting on your design choices and finding meaning to back them up. For example, I have chosen a symmetrical, center-focused setup because it adds to the theatricality and dignity of the character. The overall layout creates an egg-like shape, which symbolizes earth, fertility, and life. The animals are close to Mielikki, finding her company alluring and safe. Even the trees both yield and embrace her shape, creating a halo or cathedral-like frame, confirming her divine power. She is in a symbiotic relationship with her surroundings and is a natural part of them.

You can also tell a story by referring to things that aren't actually shown. Mielikki and the animals are looking at something outside the visible scene. This gives the viewer a hint that something has drawn their attention: the huntsman, perhaps, entering the forest and pleading to the goddess with his flattering rhymes.

Near top right
The composition of focal points provides interesting and natural movement for the viewer's eye

Near bottom right
The second version of the sketch is more detailed

Far right
Small details help to tell a story about the character

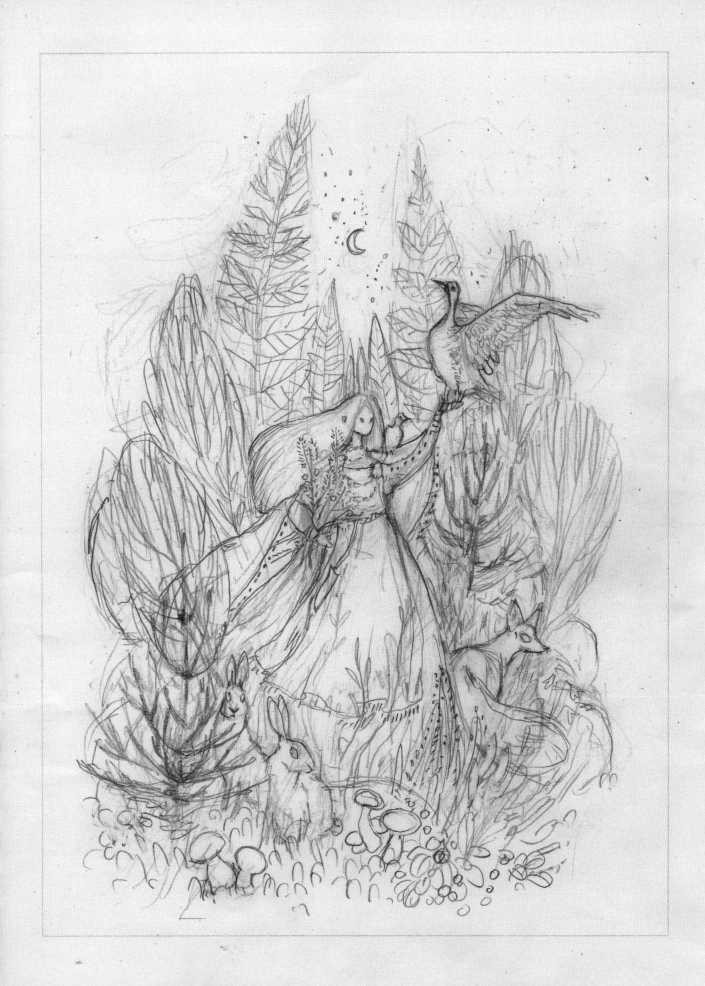

Transferring the drawing

The composition is transferred onto watercolor paper by using a light box (mine is a LightPad by Artograph). It's important to select paper that will endure wet washes and multiple rounds of adding and removing masking fluid and paint. In this case, I am using natural white 300 gsm Sennelier watercolor paper with a rough, grainy texture. I trim this paper sheet to 10 × 13 inches to match the proportions of my sketch.

Drawing outlines

I use Copic Pigma ink liners for the outlines, as they are water resistant. I prefer warm gray with a 0.05 mm tip, which creates a light and crisp line. The thin, neutral-colored lines become almost invisible under layers of watercolor. I leave certain elements (like some of the tree branches) without lines, as I will paint on them later with masking fluid.

Finished outlines

Here you can see the final light outlines. Now that the drawing is complete, I mount the paper on a piece of rigid cardboard with masking tape. I make sure that the tape is attached as tightly as possible. I avoid tapes that are meant for fragile paper types, because they tend to peel off ahead of time when using large amounts of water.

Painting tools

The main tools for my painting process are masking fluid, a few different paintbrushes, and a set of watercolors. My favorite paints are a mixed set of watercolor pans from Schmincke and Rembrandt. You can start with as few as six basic colors, which are yellow (chrome and cadmium), red (cinnabar and carmine), and blue (Prussian and ultramarine) – plus optional white – and collect a larger variety of hues later on.

Above left
The composition is transferred to a watercolor paper using LightPad, an LED illuminated light box by Artograph

Above right
Drawing delicate outlines with a warm gray pigment ink pen

Top right
The finished outlines are kept deliberately light

Bottom right
Tools for creating a watercolor illustration

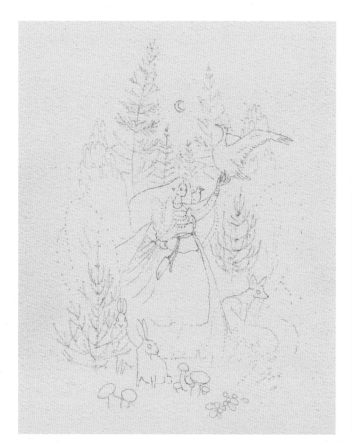

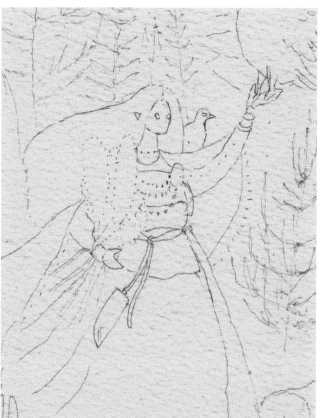

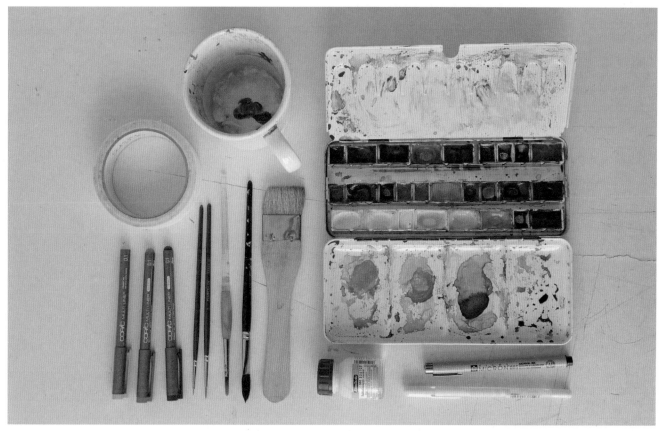

First watercolor wash

The first watercolor wash is only slightly tinted, and will create a blue-ish base hue for the entire image as well as determine the lightest value of the final palette. I use plenty of water with soft, large paintbrushes and add some more color, wet on wet, to the areas that I want to mask later on. Then I let the painting dry completely.

Masking

Masking fluid is added to the areas I want to have the lightest highlights. The brush for this needs to be slim and quite stiff; I use a synthetic watercolor brush, size 00. It is easy to ruin your brushes with masking fluid, even when washed properly with soap afterwards, so I avoid using expensive brushes! I always keep a cup of warm water and a tissue at hand, so I can rinse and wipe the brush clean every now and then as I work.

Adding layers of paint

Once the mask is dry, I add more layers of watercolor. The mask allows me to paint darker shades over the protected details, and I can even freely use techniques such as splattering or tilting the paper without compromising my highlights.

Painting details

When I want to add clear, crisp details, I paint on dry layers so that the colors do not bleed. Occasionally I add more mask or remove some of it between applying color, when I want to protect or access certain areas. I always make sure that the paper is completely dry before adding or removing the mask!

Light and color

Color and lighting defines atmosphere. This is a scene from the "nightless" night of the northern summer, which never grows entirely dark. I want the lighting to be soft and dreamy, so I avoid using stark contrasts and black. Mielikki seems to glow with her very own light, as opposed to being lit from an external source of light. This adds to the otherworldly ambience.

Colors are mixed and tested on a spare sheet. Paper tissues are useful for removing excess moisture or fresh paint from areas that look too dark.

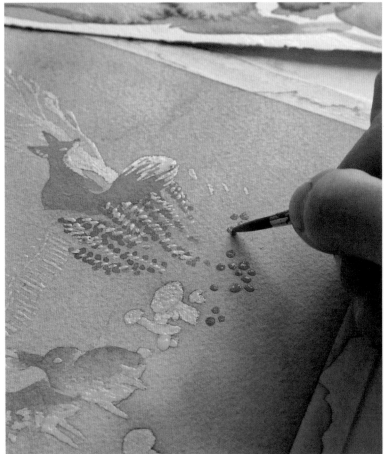

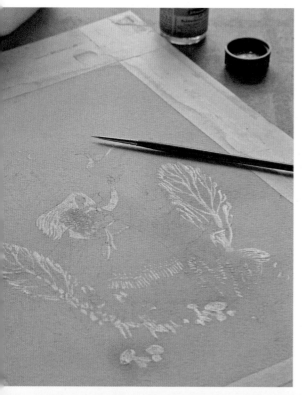

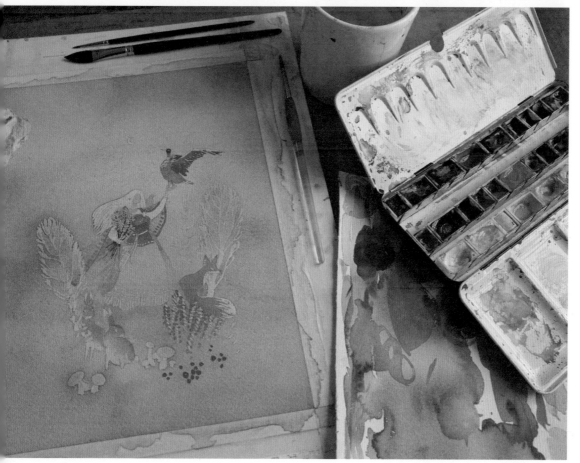

Far top left
Soft, wide brushes are
suitable for painting
the first light layers
of watercolor

Middle top left
Masking fluid is added with
a thin brush and left to dry

Near top left
The mask protects the
highlights while darker
layers of watercolor
are painted on

Far bottom left
Painting some details

Near bottom left
Colors are mixed on a
separate sheet of paper

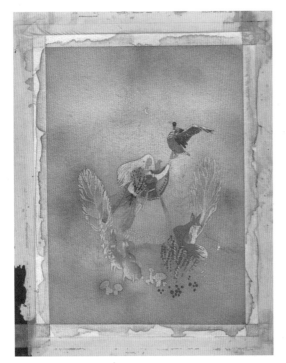

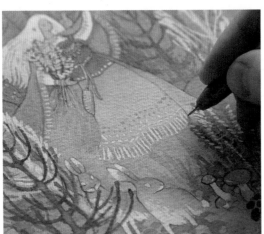

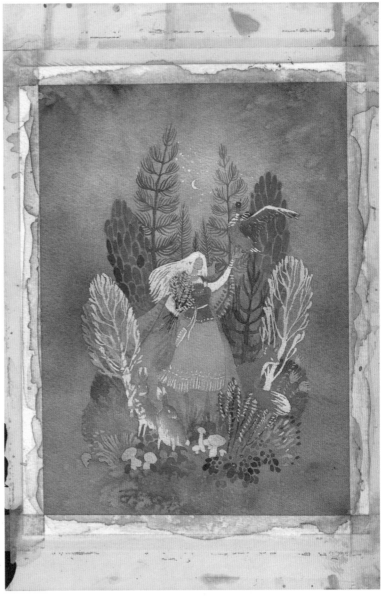

Painting progress

I tend to avoid saturated and obvious color combinations, especially when trying to achieve a magical atmosphere. For the background, I mix a soft shade of teal and let the layers of paint blend together in an irregular fashion. I use reddish brown and some lavender hues to complement the dominating blue-green color scheme. I like to juxtapose two colors that are opposite hues but have similar values. I soften the tones by using more water on the layers of paint and by mixing some of the colors with opaque white paint.

Removing the mask

I remove the mask by gently rubbing it with dry, clean fingertips. If you are using masking fluid for a longer project, bear in mind that it should not be left on a painting for more than two days. After the mask is removed, I continue to paint a few remaining details with darker paint.

Polishing details

Finally, I return to using my ink pens and revisit some of the details to give the illustration a polished look. There is a risk of overworking the lines at this stage, which would reduce the whimsical charm and texture of the watercolor, so I try to keep the embellishments to a minimum.

The final illustration

Now that the illustration is complete, the last task is to remove the tape. I peel off the tape carefully, pulling towards the edges of the paper to prevent it from ripping. I have left some empty space around the main subject of the painting, so that the illustration can easily be fitted within a mounting board when framed, or cropped to a desired size to fit different printed or digital platforms.

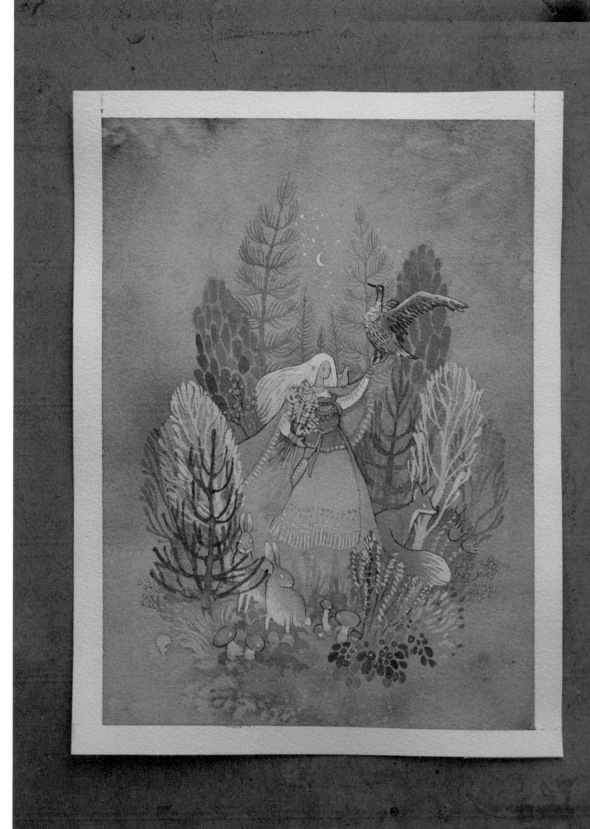

Far top left
The painting process
is halfway complete

Near left
The painting is almost
finished and the
mask is removed

Far bottom left
Polishing the details with
a pigment ink liner

Right
Finished illustration
© Ulla Thynell

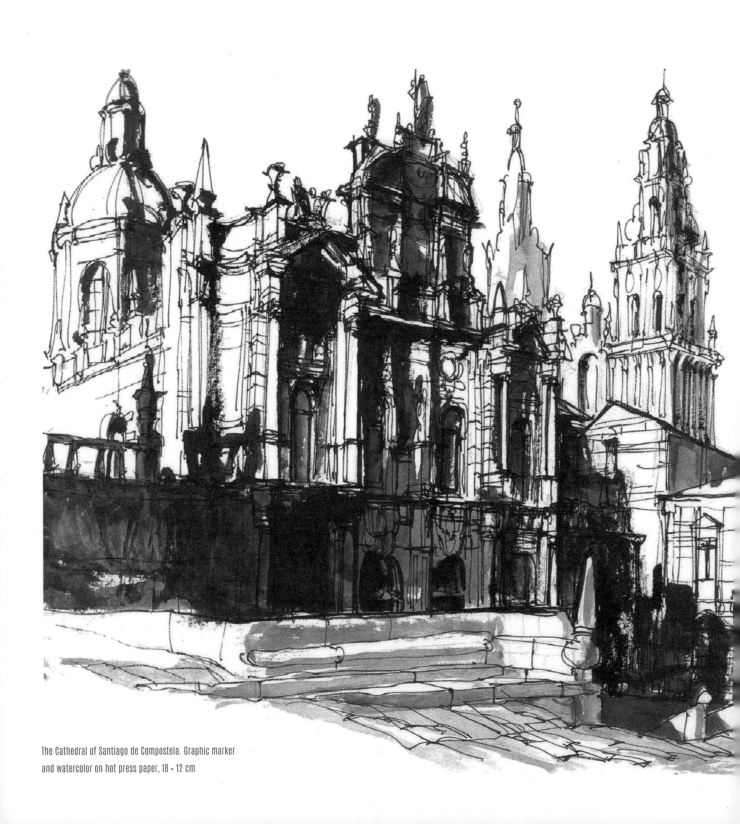

The Cathedral of Santiago de Compostela. Graphic marker
and watercolor on hot press paper, 18 × 12 cm

FROM PLACE
TO PLACE

An interview with Christian Reiske

Concept artist Christian Reiske spent over seven months hiking around Spain with sketchbooks, paints, and drawing tools in hand. We talk to him about his travels and the inspiration behind his work.

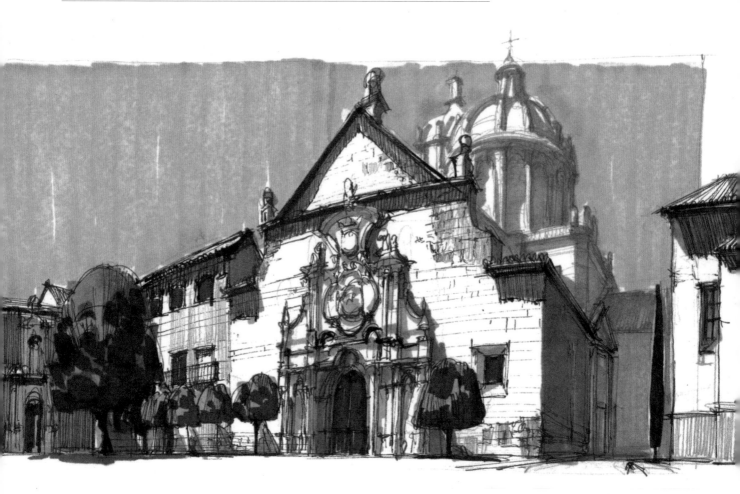

Q· Thanks for speaking to GRAPHITE. Could you tell us a bit about who you are, where you're based, and what you do?

A· My name is Christian Reiske, I was born in 1990, and I am from the northeastern corner of Germany, where there is a long coastline with the Baltic Sea and some pretty small towns. It was a great place for growing up and spending the summer, but I moved to Cologne to study design and still live there.

As a child, I loved whales and dinosaurs, but I turned them in for space ships, airplanes, and guns a long time ago. After leaving university, I took a long journey with my sketchbook,

and have turned that experience into an art book over the last two years.

Q· How and when did you discover concept art and realize it was something you wanted to pursue?

A· It must have been around 2005, when I was fifteen. I loved science fiction and was very excited for the new *Star Wars* prequel. One day I had a book in my hands that featured hundreds of illustrations about the movie; I couldn't say whether they had been made for the movie, or afterwards as some form of fan work, because everything was written in Polish and I hadn't seen anything similar

before. But I got my first glance of concept art, and I soon found out that there really was an occupation where people painted the visual content of films and got paid for it! I knew what I wanted to become at that moment and that hasn't changed over the years.

Q· Who or what are your biggest inspirations?

A· As a child, I was fascinated by my grandparents' large bookshelves. One day I found a heavy old book with the title *Life in Primeval Times*. It looked rather cheap from the outside, with a peculiar scratchy cloth binding and no cover illustration, but it turned out to be a treasure. The

illustrations were from the 1960s, by Zdeněk Burian, and are mostly outdated by now but overwhelmingly beautiful and atmospheric nevertheless. That was one of my early encounters with paintings that seemed "larger" than themselves – images that could evoke feelings and a desire to learn about what they portrayed.

Another important inspiration was the movie *Final Fantasy: The Spirits Within*, which did not gain much recognition when released in 2001, and is almost forgotten today outside of its small fan base. For me, this film towers over all other recent sci-fi movies in regards to concept art. It has the most stunning design pieces and matte paintings I have ever seen, highlighted at the right moments of the story to make them meaningful and important. The people responsible for them more or less formulated the guideline I have followed ever since: to connect realism with beauty.

Among the artists that have influenced me, Ryan Church is especially notable. He has changed his style very much over the years, but his early work on *Star Wars: Episode II – Attack of the Clones*, *Star Wars: Episode III – Revenge of the Sith*, *War of the Worlds*, and the pictures that he shared from his own time at school were overwhelmingly important to me. He set the appearance of those movies almost single-handedly and made a lasting impression on me. He was the first concept artist I ever knew, and is the embodiment of concept art for me.

Q· You're skilled with both digital and traditional tools, but do you have a favorite medium in general?

A· When I place some of the art books that I have collected over the years side by side, there is a striking shift in the appearance and techniques of concept art. You can see the decline of traditional illustration with watercolor or markers, to the dominance of digital 2D, and 2D's disappearance again in favor of 3D renders. However, I believe that a skilled 2D artist will always prevail in the competition, and it is the medium in which I try to become as good as possible. My traditional tools will stay to help, but mostly are not part of my ongoing design process and results.

Because I had illustrated almost entirely digitally for many years, I had to teach myself traditional techniques like watercolor and gouache afterwards, and it was anything but easy. I could not simply translate digital achievements directly into traditional tools – it's a completely different world. However, the efforts were absolutely worth it, and although traditional tools are often a side note to concept art today, I regard them as simply too beautiful to ignore.

Left
Plaza de la Universidad in Granada, one of the places I visited during my first month. Graphic marker on hot press paper, 18 × 9 cm

Below
The town square at Vic, Catalonia. I had a great deal of fun in small, well preserved towns like this. Graphic marker on hot press paper, 16 × 11 cm

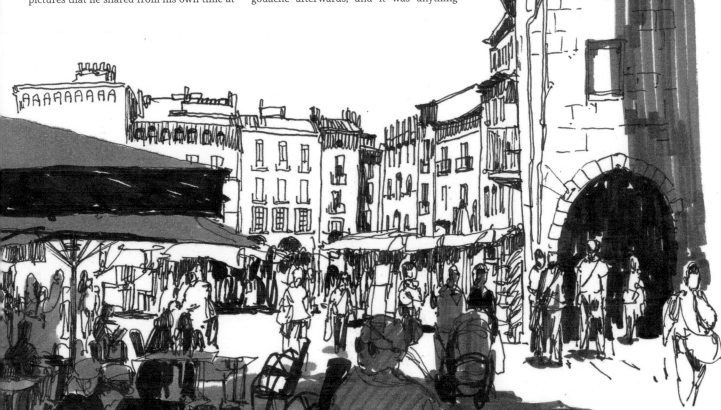

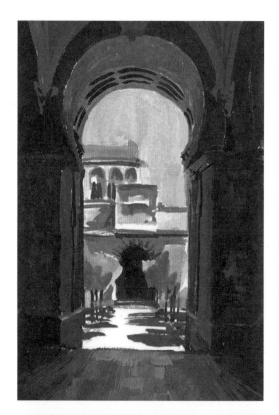

Top left
Entrance of the former Great
Mosque of Córdoba. Watercolor
on hot press paper, 7 × 11 cm

Middle top
At the edge of the Pyrenees.
Gouache on hot press
paper, 10 × 7 cm

Top right
A small group of houses
in the central Spanish
highlands. Gouache on hot
press paper, 11 × 7 cm

Far bottom left
Small trees and a stone wall
around a vegetable garden in
Galicia. Watercolor on cold
press paper, 18 × 13 cm

Near bottom left
View over a bay at Fisterra, last
town on the trail. Gouache on
hot press paper, 14 × 10 cm

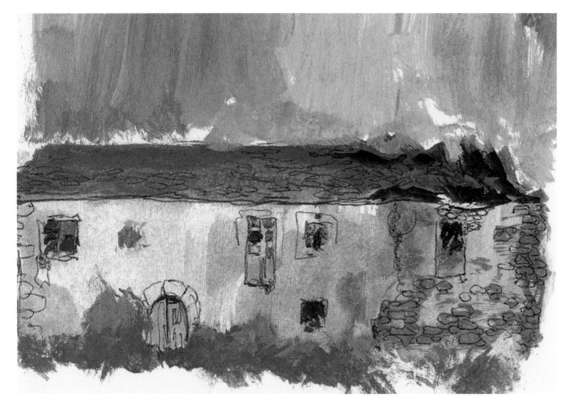

Top left

A sloping street within the wavy center of Santiago de Compostela. Graphic marker on hot press paper, 15 × 5 cm

Bottom left

An abandoned house in Galicia. It was a great subject to paint, and it was for pictures like this that I traveled, after all, but it was sad to see many beautiful locations that didn't seem to have a future. Gouache on cold press paper, 12 × 10 cm

Bottom right

The town of Cuenca, pencil on hot press paper, 18 × 9 cm

Q· Tell us about your travels in Spain and the sketching project you set for yourself.

A· Making a long journey alone somewhere was an idea I had for many years, but it faded almost completely during my years at university. It simply didn't come into my mind any more. But after finishing university, I felt that now was my last chance to pursue the idea in the way I imagined. Originally I wanted to make a round trip through large parts of Europe, but dismissed it in favor of staying in one place for a longer time. Spain is considerably larger than Germany, so I would definitely not get bored!

The thought of a dry landscape with ruins of churches or Roman buildings, great subjects for a sketchbook, excited me more than any other place. I could combine an adventure with a plan to make something useful for my artistic career.

I spent the first month in Andalusia, improving my Spanish, hitchhiking from place to place and getting past the anxiety of not knowing where I might be the next day. Everything turned out well and I chose to continue on foot along the network of pilgrimage routes to Santiago de Compostela in northern Spain. This trail passed through

"It is only you and your drawing, and all other things fade into the background"

sparsely populated regions, with a bigger town only once a fortnight, but I liked the calmness very much.

The final two weeks along the way from Galicia to the Atlantic Ocean turned out to be the greatest highlight, almost like a different country. I walked to the coast through sunken paths in subtropical forests that bore no resemblance to the south.

My next adventure was through Catalonia and central Spain until the autumn. This was a very different location again, with mighty canyons and almost desert-like areas which filmmakers regularly visit to shoot movies nowadays. The central highlands were sparsely populated and the summer had turned everything to a color palette of brown and beige. It didn't look very inviting at first, but the people were very kind and helpful, and I definitely had a great time there.

Q· What did you take away from the journey? How did you feel when it was over?

A· I hadn't undertaken such a trip before, and I knew I had to organize everything by myself and count only on myself. As a rather introverted person, this prospect definitely gave me some emotional goose bumps! The first week in Cádiz, however, went exceptionally well and was crucial in convincing me that this was a good plan after all. This impression did not change over the course of the following seven months, and I was really happy to have started the journey. In the end, I just felt a deep satisfaction.

Q· Drawing on location can be daunting at first, even embarrassing if there are other people around. Do you have any tips for artists who are trying to improve that skill?

A· It was challenging, maybe, but never embarrassing for me. Drawing on location is a great way of getting in touch with people when they stop to take a look over your shoulder. People recognize that you are not just there for cheap amazement or to take photographs that look like everyone else's, and it does not matter how good you are. With this in mind, it is only you and your drawing, and all other things fade into the background. Just do it.

Q· Finally, how do spend your free time, if you have any?

A· From time to time I like to work on screenwriting, for which I have developed a passion. It doesn't need many resources – just a notebook nearby.

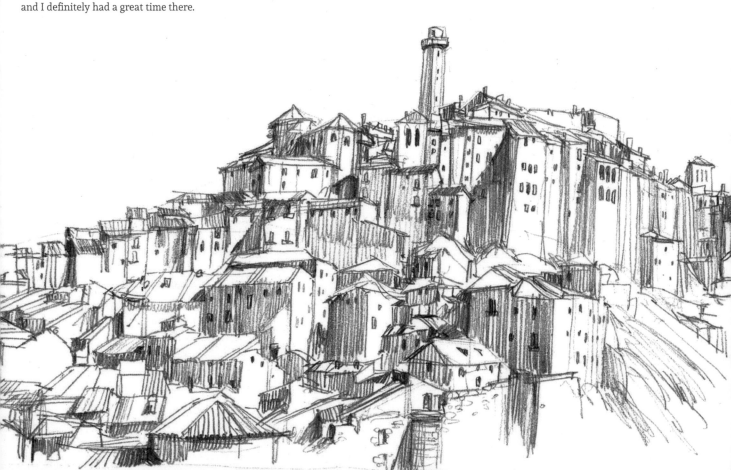

DESIGNING DINOSAURS

Sketching and painting a creature concept with Jordan K. Walker

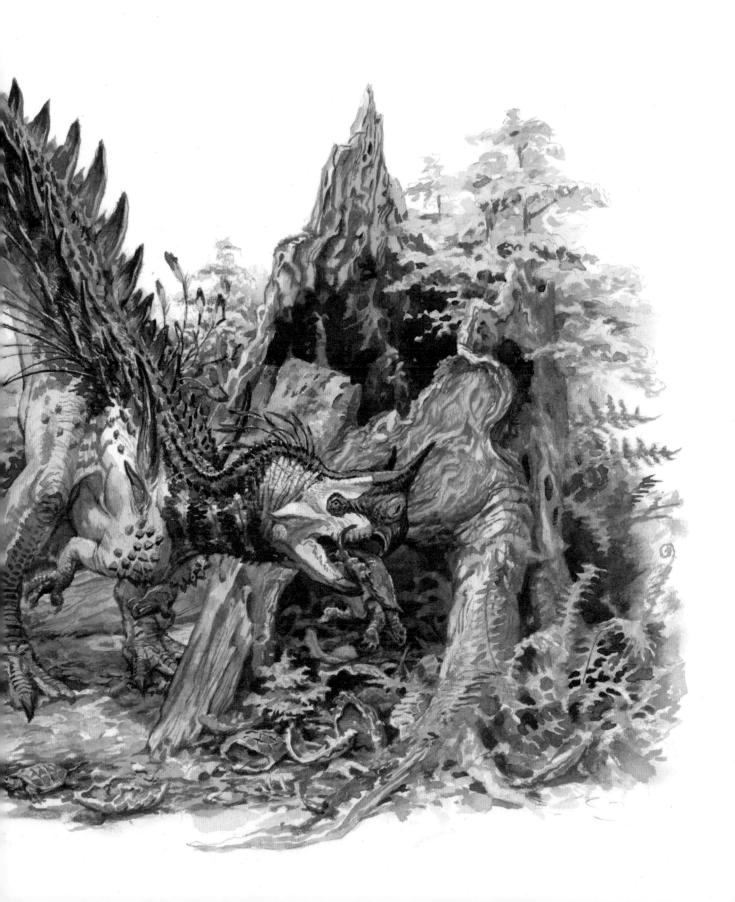

Illustrator and natural history enthusiast Jordan K. Walker shares his process for researching, designing, and rendering a fictional dinosaur with pencil and watercolors.

Left
While it is great to sketch anywhere, I find a dedicated studio space to be invaluable for any in-depth creative work

Top right
These are some of the tools I use most often for drawing

Bottom right
#1 *Psittacosaurus*
#2 *Kentrosaurus*
#3 *Diabloceratops*

Workspace

Dinosaurs were one of the most magnificent and diverse groups of animals ever to roam the planet. What might have happened to the prehistoric world if theropod carnivores like *Tyrannosaurus* were wiped out by disease before they could flourish?

Many of the famous plant-eating herbivores such as *Triceratops* and *Stegosaurus* belong to a single family, Ornithischia, and share a common ancestor. In this tutorial, I will show you how I use pencil, watercolor, and principles of creature design to create a carnivorous ornithischian that evolved in an alternate timeline where *T. rex* never existed.

Before I begin designing this creature I'll give an overview of my studio. On the days devoted to sketching and watercolor work, I have a sturdy desk as my main workspace, with room to spare for a computer and reference books.

An adjustable lamp is clamped to the side of my desk to provide light where it is needed, and there are plenty of deep drawers to store finished work. Inspirational work by other artists hangs on the walls, and I house a menagerie of plant and animal specimens to draw from.

Drawing tools

While pencil and paper are staples for nearly every illustrator, the options to choose from can seem overwhelming. Pencils are rated on a scale from B to H, up to ten variations on each end. Pencils in the H range make light marks, and are good for underdrawings. B pencils make darker marks, and I keep a variety around for rendering. A handy metal pencil extender makes it easy to use old pencil stubs. I like to draw on smooth Bristol paper, and use a Maped eraser to erase small details without any smudging.

Research

Prior to starting a new creature design, I like to study examples of similar real-world animals. This is especially important here, because the dinosaur I design should appear to have evolved naturally. *Psittacosaurus* was an early ornithischian dinosaur with a bipedal stance and interesting patterns on its chest. Many ornithischian dinosaurs like *Kentrosaurus* were characterized by their abundant spines and plates, which served defensive and decorative functions. Ceratopsians like *Diabloceratops* had powerful beaked jaws, and my predatory ornithischian could use similar jaws to crush the armor of its prey. These are all features I'll incorporate into my design.

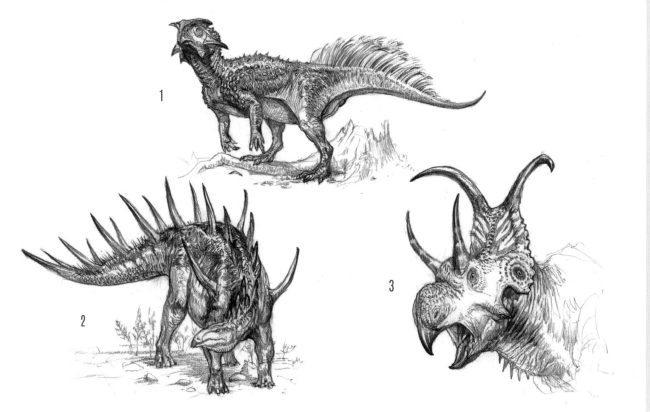

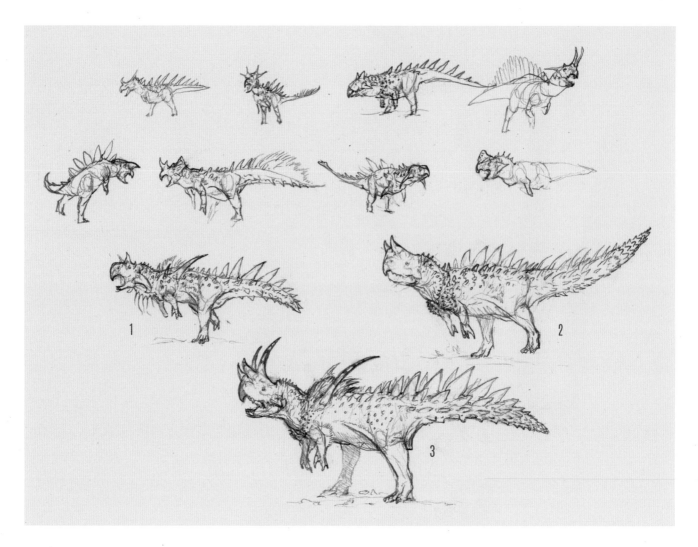

Design thumbnails

With these design features in mind, I begin work on thumbnail sketches. The first round of sketches is always rough and uncertain. It can take dozens of iterations before the good ones arrive! I experiment with arrangements of spiny armor to ensure the creature is visually related to other ornithischians. This animal is a mid-sized predator, and while it has heavy spines to protect it from larger carnivores, it should still be able to sprint after fast-moving prey. #1 and #2 have the best sense of balance in this regard, and #3 combines my favorite attributes of both.

Profile drawing

After arriving at a good design through the thumbnailing process, I create a larger drawing of the creature. This animal is very bulky, with a long, muscular tail serving as a counterweight to its heavy torso and head. Its horns are shorter than those in the thumbnail, so that they can be used more practically to batter rivals without breaking. *Kentrosaurus*-like shoulder spines protect it from aerial attacks by larger predators, and the plates on its tail can be flushed with color to intimidate other dinosaurs.

Threat display

This dinosaur's powerful jaws are perfectly adapted to break open turtle shells, so I imagine it stakes out a territory along a stream or lake where such prey is plentiful. Males and females alike would fiercely defend their territory, and would meet any approaching competitors with a flamboyant threat display. The bumpy patterns on the animal's chest are visually striking, and long feathers along its neck and thighs can be raised to frighten interlopers. This kind of threat display is common in modern birds, and striking patterns were probably used in a similar way by other ornithischian dinosaurs.

Above
A sampling of some thumbnail designs, ranging from rough scribbles at the top to more refined designs below

Top right
A profile view of the final design

Bottom right
In this sketch the creature is approaching the viewer with a threat display

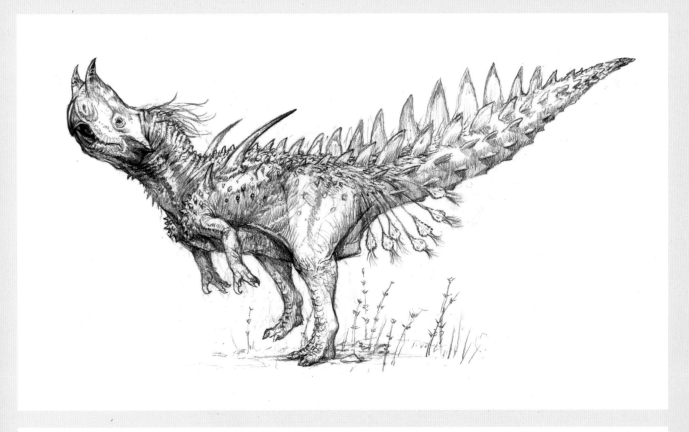

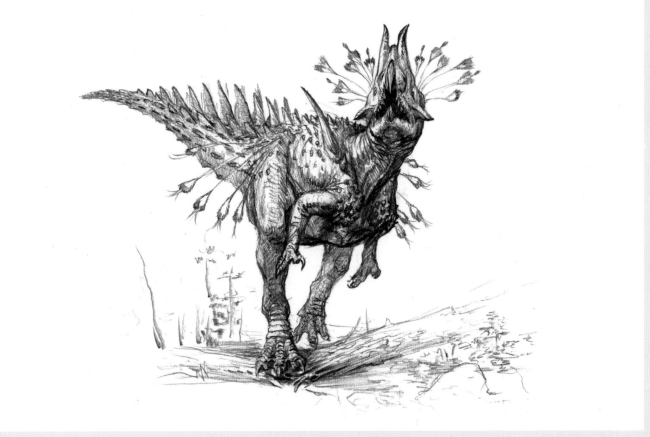

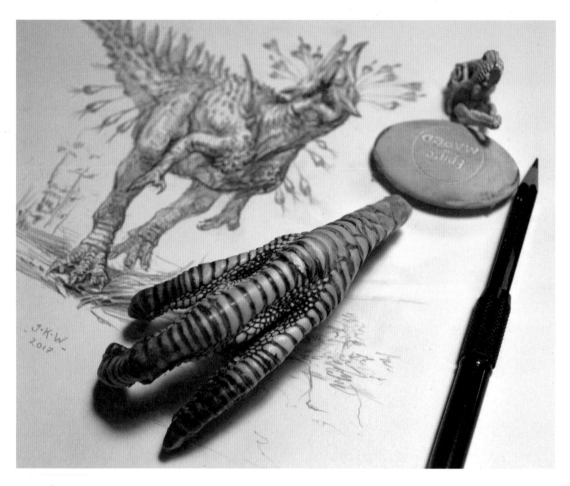

Left
It is useful to have physical reference on hand when designing and drawing creatures in different poses

Top right
The skin patterns and coloration of a creature help to determine where it lives and how it behaves

Bottom near right
Outdoor adventures are not only refreshing after days spent in the studio, but can provide a wealth of inspiration and information

Bottom far right
Compositional thumbnails, like design thumbnails, begin as vague shapes and end as more refined little sketches

Reference objects

I use many kinds of reference when inventing new creatures. Images in books can provide insight on anatomy and texture, while wildlife documentaries can shed light on different ways creatures can be posed.

One of the best ways to understand a form is to have something physical in front of you, and this is where a library of specimens in your studio is incredibly helpful. For this drawing, I enlist the help of a turkey foot to get a better idea of scale patterns, and a poseable plastic skull to understand how my creature's head would look facing forward.

Skin patterns

This creature primarily hunts large turtles, but this is no easy feat. Although they bask in the sun on logs emerging from streams, most turtles can jump into the water and disappear instantly. To compensate for this,

my dinosaur needs to have cryptic patterning to blend into creekside forests and ambush its unsuspecting prey.

I scan my profile drawing of the creature and print six copies on a sheet of paper. I draw over these with pencil, trying different patterns inspired by real-world jungle predators. Any of these could work, but I prefer the way the form reads in #2.

Outdoor inspiration

Now that my creature design is more or less finalized, I need to decide how to incorporate it into a more fleshed out illustration. I live in the temperate rainforest of Western Oregon, and so I often hike into the woods to find reference and inspiration.

On my expedition for this illustration, I come across a magnificent giant spruce trunk. I also observe several squirrels eating pine

cone seeds while discarding the shells in piles that must have accumulated over days. My dinosaur could have a habit of bringing turtles to a particular trunk, and piling shells and bones inside.

Composition thumbnails

Now that I know the setting and story for my final illustration, I can begin another series of thumbnails. I break the image down into the simple shapes of the stump, the dinosaur, and a turtle carried in its mouth.

This illustration should be a vignette that fades into the white of the page to accommodate text placement, and therefore all of the elements should ultimately be contained within the rectangles that I've already drawn. I experiment with many different compositions and settle on a couple of options which I enlarge at the bottom of the page.

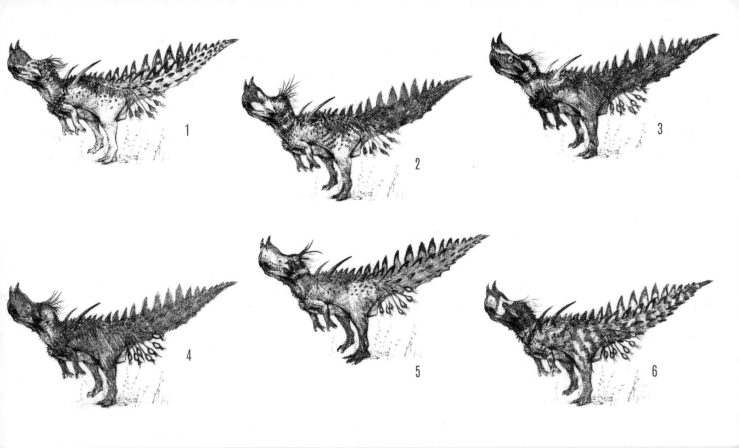

1
2
3
4
5
6

Final drawing

I like the backwards "S" curve of the creature in the bottom-left thumbnail in the previous step, and the narrative told by it dropping a freshly caught turtle into its storage stump. Following this design, I create a larger drawing on a sheet of 300 lb (or 640 gsm) watercolor paper. I use a relatively hard 2H pencil to lightly indicate the placement and structure of all the major forms in the composition. I try to resist the urge to go into detail; this drawing is only a foundation for my final painting, and all of the rendering and detailing will happen later.

ARTIST'S TIP

Make the most of your pencil

If you draw with a wood pencil rather than a mechanical one, don't forget that you can make marks with more than just the point. A pencil can be sharpened with a long point sharpener or by hand with a knife to lengthen and alter the shape of the exposed graphite. You can use the sides of your pencil tip to achieve many interesting marks, and can cover large areas in a single stroke. If you use a variety of marks and line weights in a drawing it becomes much more interesting, and naturalistic textures can be achieved with little effort.

Right
This is my final drawing. It's not really finished in itself, but is the scaffolding for the paint layers to come

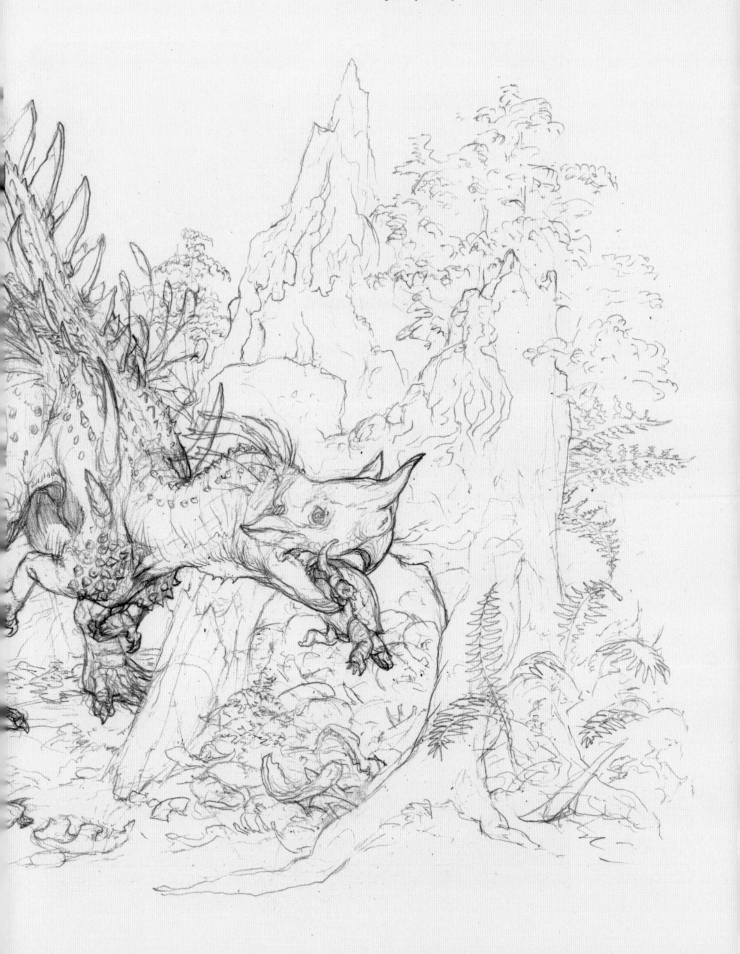

Near top right
This is my typical watercolor setup. Mugs can be good containers for art supplies, so long as you don't confuse them with your tea mugs!

Near middle right
The initial wash is one of the most nerve-wracking stages of a watercolor painting

Near bottom right
When rendering a piece, it helps to work from large to small: work on large areas before moving into detail

Far right
Newly discovered species are traditionally given scientific names in Latin. I call this animal *Quiportaverit turtur*: the one who carries turtles. Final image © Jordan K. Walker

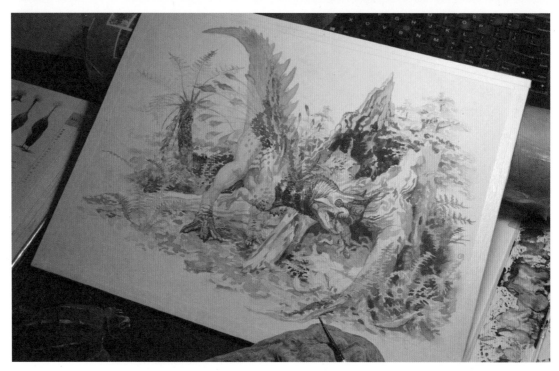

"The lush forest is a strong complement to the creature design"

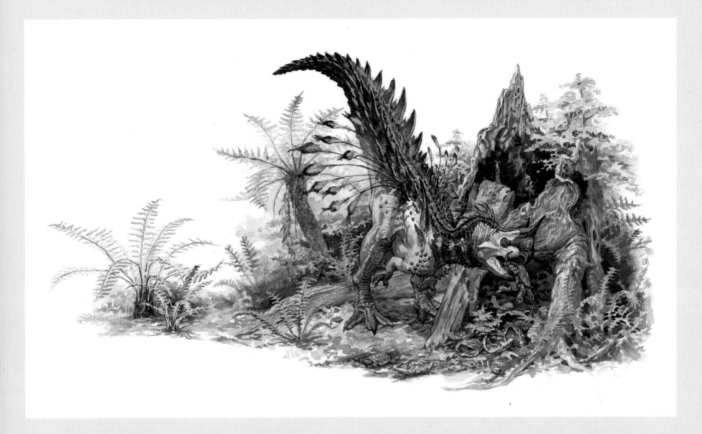

Watercolor tools

Watercolor is an unforgiving yet rewarding medium. I like to use a small Kuretake Gansai Tambi pan set, with dry cakes of paint that can be activated with water and used in thin washes or opaquely like gouache. I use the small plastic cover that came with the set as a palette to mix on, but any plastic or glass surface will do. I keep my watercolor brushes in a big mug with my pencils and other drawing supplies. Large round brushes with a fine point can yield a variety of marks, and flat brushes are good for wide washes.

Applying wash

When working in watercolor, I paint from light to dark. This means that before I do any detailed painting, I need to lay light washes of color over large areas of the piece. These washes represent the brightest highlights across the whole painting, and are usually very saturated. They help to separate the painted areas from the white page early on, but leave the piece in a very strange and disjointed-looking state. It's easy to get discouraged at this stage, and I have to remember that the piece will mellow when I bring in darker tones.

Rendering

After the initial wash, I start to bring things together. I usually begin by rendering the background elements in my piece. I paint patches of dark green and blue into the background and bring out the foliage around the stump, constantly referring to photos from the woods and my live plant collection as guides for color and value. Sometimes I allow soft edges to fade into the page; other times I chisel darks around light shapes to bring them forward in sharp relief. The same principles apply when I paint the stump, the dinosaur, and his tasty turtle meal.

The final painting

After many hours of work, I arrive at the final illustration. The creature is clearly related to other ornithischian dinosaurs, and is an accomplished predator. The lush forest is a strong complement to the creature design.

I superimpose some additional ferns over the original image in Adobe Photoshop to extend the composition for a better fit on the printed page. This creature was designed for a very specific brief, but the process I have gone through can be applied to any kind of creature design or illustration, and the same basic principles are relevant whether you work traditionally or digitally.

CONTRIBUTORS

Jason Lee
jclee.info

Giselle Ukardi
instagram.com/giselleukardiart

Daniel Pagans
danielpagans.com

Anaïs Maamar
anais-maamar.tumblr.com

Dwayne Bell
dwayne-bell.com

Ulla Thynell
ullathynell.com

Christian Reiske
artstation.com/konzeptosaurus

Jordan K. Walker
jordankwalkerart.com

THE GRAPHITE TEAM

Marisa Lewis
Editor

Matthew Lewis
Graphic designer

Adam J. Smith
Proofreader and contributor
strangerwritings.com

Simon Morse
Managing editor

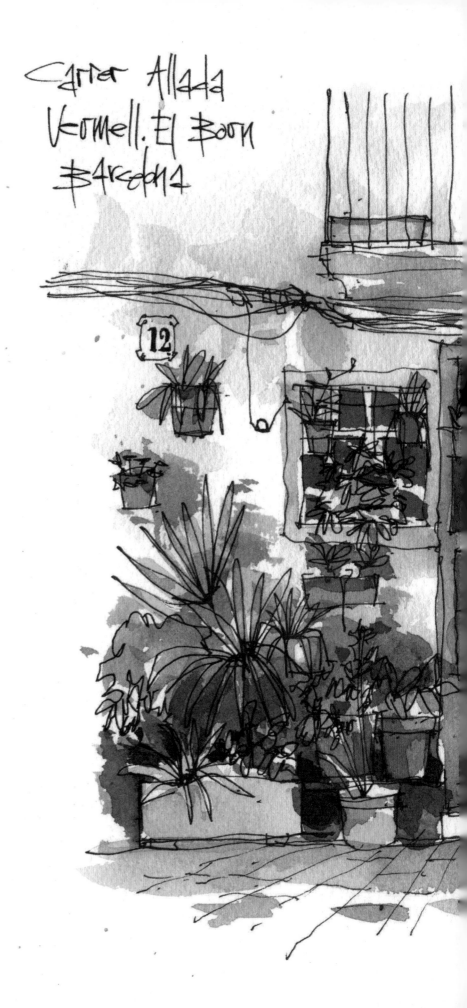

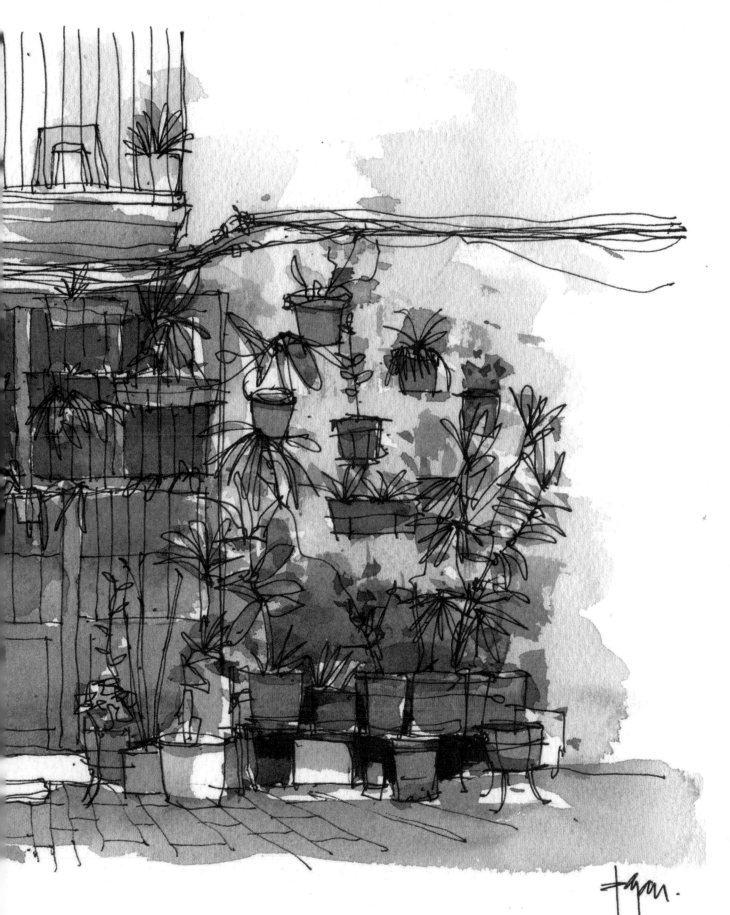